the BUSINESS of ACTING

LEARN THE SKILLS YOU NEED
TO BUILD THE CAREER YOU WANT

BRAD LEMACK

Ingenuity Press USA

Published by Ingenuity Press USA.

This publication is designed to provide accurate and
authoritative information in regard to the subject mat-
ter covered. It is sold with the understanding that the
publisher is not engaged in rendering career counseling
or other professional services. If expert assistance is
required, the services of a competent professional person
should be sought.

Library of Congress Control Number: 2001098023

ISBN 0-9715410-0-0

Printed in the United States of America

"*The Business of Acting* is packed with critical information that will benefit every actor. It helped me realize how focused a person entering this business today must be in order to succeed.

The information and worksheet on tax write-offs for actors alone is worth potentially much, much more than the cost of the book."

Isabel Sanford,
Emmy Award–winning actress and
star of the television series "The Jeffersons"

"I wish I had *The Business of Acting* when I was first starting out. It would have helped me to understand the difference between talent and skill in the acting process. Brad's perspective on casting directors put a whole new spin on that part of the business for me. His report and explanation about potential new regulations and changes in the laws impacting how agents and managers conduct business is very important for all actors to know about.

This book has helped me rethink my career strategy in a very positive and supportive way."

Laura Bryan Birn, actress
"The Young and the Restless"

"Finally, a comprehensive book addressing the issues we actors face in the pursuit and growth of our careers. This book analyzes

the business of acting for the actor of the 21st century. Brad has developed and presents a very practical and knowledgeable approach to the complexity of life as an actor and distills his perspective in a comprehensive and supportive form without any of the usual Hollywood hype. This book is enormously helpful to those of us already in the business, and it is invaluable to the actor just starting out.

I have great admiration for Brad's honesty and directness, both of which are the hallmarks of this book."

<div align="right">

Henry Polic II, actor, director
and co-star of the television series "Webster"

</div>

CONTENTS

ACKNOWLEDGMENTS

I WOULD NOT have been able to write this book without the support, involvement and patience of many people. The first person to step forward with guidance and information was my friend K Callan, a talented actress and a passionate writer. K has written many popular books for actors, and it was her assistance in the beginning of this project that opened the many doors necessary to produce this book.

This volume is the result of my own career journey, which has been molded by my association with many clients, colleagues, students and friends over the years. This book is the result of the many lessons I have learned from them all along the way.

I have learned that perspective, objectivity and an ethical grounding in support of things you value are vitally important to have and to maintain in any business, particularly in this business. It can become so easy, too often, to become distracted otherwise.

I have had the good fortune of working with clients who have trusted both my perspective and my objectivity, as well as clients who have provided me with tests of personal endurance on many occasions. We have all grown in and from this process. It serves as a constant reminder of how challenging and rewarding this

business is when both client and representative strive to be the best they can be all the time.

I am grateful to the actors whose names compose my cumulative client roster from the past 20 years. That list contains the names of talented people I respect who have allowed me to help them map and pursue their own career journeys.

My work in the college arena has given me the opportunity to help mold students' youthful enthusiasm and passion into energy and focus that fuel their careers. It is a gift to sit with them in class each week of the semester and watch them in the preparation of the journeys on which they will soon embark. Thank you, Geraldine Wallach, for opening the first doors of academia to me. Your support and encouragement have fueled my passion in this arena.

All of these experiences have helped me see that true success is not a single place, or a particular opportunity you one day arrive at, nor is it material possessions to show for what you have achieved. I have learned, instead, that success lies in one's ability to recognize and enjoy all of the small stuff that happens between people along the way.

In recognition of some of the most instrumental people along my journey so far, special acknowledgment must go to Mark Saucedo for his never-ending love and support; to Isabel Sanford for her trust, for her friendship and for teaching me that, no matter your age, no matter your achievements, the best thing that could ever happen to you could still happen tomorrow; and to the loving group collectively known as my family, from whom I learned most of my "notice me" skills early on.

The development of any project demands an objectivity that can become difficult, if not impossible, for its producer to maintain. Recognition must also go to a few special people who were involved with the journey of this book. They were the first to read

what I wrote, and served up the challenges and questions that helped shape what you are reading now. Thank you, Stephen Calamita, Pamela Roylance and Lancer Dean Shull. They are remarkable editors, friends and colleagues whose contributions were enormously valuable to me and to this project.

Now let's get to work.

<div align="right">Brad Lemack</div>

FOREWORD

WHEN I FIRST STARTED pounding the pavement on the streets of New York looking for work as an actor, all I wanted to do was act. All my life, all I had ever wanted to do was act. Even in elementary school, I loved being the center of attention.

I was never really aware that there was a process to how the business of acting works. I just kept pounding the pavement and pursuing opportunities to act as often as I could. I thought that as an actor all you really had to do was audition, audition and audition again, which could, hopefully, lead to work, work and more work. It seemed like a simple enough concept to me.

Not until much later did I recognize that there is a big difference between an acting job and an acting career. I spent my early years as an actor going from one acting job to another, from one play to another. But then I wanted more. I wanted that career. I wanted to be a "movie star."

Looking back on it, I am grateful for the opportunities that were given to me and for those that I generated and earned for myself. I believe that things happen when they are meant to happen, but I sometimes wonder how much sooner the career part of my acting life would have come along had I been aware that I

needed to do more than just be the best actor I knew how to be. I was busy raising a family and holding down up to three jobs to pay the bills while pursuing my acting career. Who had time to be a businessperson as well?

I learned that acting was more than just going on an audition and getting (or not getting) a part. I learned that in order to have longevity, in order to have a career that grows, fulfills and challenges, you need to know how the business works. You need to know what expectations the business will have of you. You also need to follow your instincts and the advice of those around you whose opinions you value and whose input you trust.

I've been very blessed with a wonderful career and professional and public recognition that humbles me. I also know that you can achieve that, too. What matters is how you approach it. Take care of business, use the skills you will learn in this book, maintain your focus and opportunity will find you.

The Business of Acting is packed with critical information that will benefit every actor. Use it to your advantage.

I wish you success and a long-running series of your own!

Isabel Sanford

PREFACE

I WROTE THIS BOOK because I saw a need for actors to have access to a collection of objective information that will benefit them. I wrote this book to teach actors of all ages the skills they need to build the careers they want. I wrote this book to address the issues and obstacles actors face and how to conquer them. This book is meant to have an impact on your personal perspectives on the business of acting and the journey of your career.

I often see in my students, and in my day-to-day encounters with professional actors, a general lack of procedural protocol that will get in the way of their achieving their goals if they do not make some adjustments to how they deal with other people. But first they have to be aware of whether their behavior is sending the wrong message about the kind of person they really are.

Many times, in conversations with actors, I find myself unable to stay focused on what they are saying because I am distracted by their attitude or their behavior. It isn't that their attitude or behavior is necessarily bad, it is just that it is inappropriate to the situation. We will take a closer look at such issues in several chapters of this book.

At other times I am appalled by the quality of materials

submitted to me by actors seeking representation. Attitude and behavior play big roles in photos and support materials submitted, as well.

Long before I have a chance to determine if any of these actors has a potential that intrigues me, I find myself immediately judging them based on my personal perceptions of them. These perceptions, or impressions, are rather quickly formed based on my initial responses to their attitude, their behavior, their body language and their presentation of themselves, whether in person or by photo. I'm not alone. This happens all the time. You do it, too. We all do. It's human nature.

I regularly encounter two categories of actors. One category comprises young, vibrant, energetic people eager to grab their place in the spotlight, yet they have no real concept that they will have to work hard to get there. They are actors who are seeking others (i.e. agents and/or managers) to help get them from where they are now to where they want to be without owning any real responsibility in getting there.

The other category comprises those actors who have already been working in the field but who are not happy or satisfied with where they are at this point in their career. They are actors who are quick to blame others (i.e. agents and/or managers) for why they are in the career slump they feel they are in, yet they have not stopped complaining long enough to realize that they alone are responsible for the situation they find themselves in.

While this is not a book on the psychology of actors, it is a book about behavior, attitude and actions. You will see how lack of skill, inappropriate behavior, a poor attitude and selfish actions can be very destructive to an actor, both personally and professionally. You will also learn how to avoid letting this happen to you.

I wrote this book because I want to teach actors and those who

wish to become professional actors about the process of developing and maintaining a career, or relaunching a career, in this business. I wrote this book because I want to show actors that if you simply look inward first, you will show the world a truer picture of who you really are. I want to make actors aware of the role that perception plays in the kind of careers they have.

I wrote this book to encourage and support students of the performing arts to pursue their careers with all the strength they can muster, and to temper that enthusiasm with a dose of reality and responsibility.

I also wrote this book because I know how hard it is for those actors who already are professionals in the field to move their careers upwards. I know how frustrating and debilitating this can be. I hope that by reading this book those actors will gain a new perspective on a business they have already been a part of. I hope that this perspective and some of these approaches will help them take a healthy responsibility for the next phase of their career journey.

I have discovered that many actors, especially recent college and university graduates, take the first steps of their career pursuit with a sense of entitlement, a sense that opportunity should just open up to them. This is a dangerous attitude. Any career worth having in any field requires passion for the pursuit, the ability to know that there is still plenty for you to learn and absorb, and the development of critical skills that will help take you beyond that first break.

This is a book about skills, not talent. You will read more about that shortly.

I wrote this book because I recognize that without the patience of tolerant mentors, I would not have had the opportunity to develop the skills I have learned so far in the journey of my own

career. After 20 years in this business, I still hone my skills every day.

I have learned about this business from personal experience, clients, colleagues and friends. I have also learned that before you set out to achieve success for yourself, it is important to identify what success is and what it means to you; otherwise it will be impossible for you to recognize it when it arrives. It is also important, from the very beginning, to set your sights and your strategies for success on goals that are meaningful, realistic and attainable. If you do not, you set a pattern for a lifetime of career disappointments when things fail to happen in the time frame you created.

My own career has been filled with a tremendous variety of opportunity and exposure. From news to public affairs, from stand-up comedy to sit-down interviews, from publicist to talent manager, it has all been—and continues to be—an incredible journey filled with lessons I am still learning and processing.

From this point on, I will not be referring to "actors" in the general, third person sense. I will be referring directly to *you*. As you begin to consider the possibilities and recognize your responsibilities, a focus, an understanding and a process that will serve you will begin to emerge.

The business of acting awaits you.

INTRODUCTION

THE BUSINESS OF ACTING rarely has anything to do with whether you have any talent as an actor. I contend, instead, that it has *everything* to do with developing the personal business skills you will need to generate the opportunities you want to build the career you desire.

Have I lost you already? Let me explain my philosophy.

There is a huge difference between talent and skill. They don't even belong in the same sentence, really. That is why your future success depends so critically on you being able to understand the difference between the two and to understand what that difference means to you.

Either you are born with talent or you are not. Either you have the gift or you do not. Actually, whether or not you have talent does not really matter if you want to be an actor. Many might disagree, but I contend that it certainly will not be the deciding factor in your getting started professionally, in building your career, in getting auditions or even in getting work. In fact, sometimes having talent can be detrimental to an actor. Many might disagree with that, too. But I contend this is also true. You'll understand why and how not to let your talent interfere with your work later.

What you are not born with, you acquire. While talent itself cannot be acquired, the skills to propel you forward in this business can be learned. In reality, it is the skills you develop, not the talent you have, that will make the difference between whether you just get a series of jobs or build a thriving career. Play your cards wrong and you run the risk of not even getting a single job at all.

You will start by setting your own agenda. You will also start by creating your own personal business plan. You will learn how to map out your personal journey to career success by acquiring and implementing the skills you will need to achieve your goals.

You will not go it alone. I will be with you through every step.

SKILLS TO BUILD A CAREER ON

"THE BUSINESS OF ACTING" will introduce you to the four categories of critical skills that you must acquire to build the career in acting that you want. In this book you will learn what those skills are, what they mean, why you need them and how to develop them. You will also learn how these skills apply to the business of acting and to your career as an actor. Once you understand what they are and how to use them effectively, your career journey will be a prolific and successful one. As you read this book, you will see how implementing these skills will impact your professional relationships and generate opportunities for you.

These four skill categories are:

✦ Behavior
✦ Communication
✦ Awareness
✦ Perception

Let me give you a brief look at what each category classification means from *The Business of Acting* perspective.

Behavior skills:

How you behave, the attitude you display and how you respond in and to personal and professional situations says a lot about the kind of person you are and about the kind of actor you will be to work with. You will see that negative behavior can stand between an actor and an opportunity. You will also discover that positive behavior can land you an opportunity that can easily pass over someone else whose behavior is questionable. But first you have to be able to recognize and assess your own behavior and come to terms with whether or not your responses to certain situations are appropriate or inappropriate—helpful to you or harmful to you.

You will see that sometimes it is easy to engage in negative behavior without being aware of it. That is why developing keen self-awareness skills is so important to this process.

Communication skills:

How you say what you say can often be far more significant then the contents of the message itself. Learning how to communicate effectively is a key skill lacking in far too many people. This applies to both your verbal and written communications, as well as to what your body language is saying for you. Most actors have no trouble saying what they want to say, but packaging their words appropriately is a skill many have not yet learned. It is a skill you must master.

Honing your communication skills also includes perfecting your listening skills. Listening should be at least 50 percent of your interaction with others. Whether in an audition situation or on a set, your ability to listen and to hear what is being directed

at you can make a significant difference in your ability to succeed. Listening is about taking direction. Listening is also about taking time to stop and learn.

AWARENESS SKILLS:

Self-awareness will get you in touch and keep you in touch with who you are and how you feel. Awareness of the people, circumstances and environment around you can keep your behavior an asset to your career. Self-awareness is about being sensitive to situations around you all the time. Self-awareness is also about being able to size up a situation in order to gauge your appropriate next step. What is the mood around you in the casting office? What is the mood on the set where you are working? Learn to be aware of your own presence in the presence of others. Learn to be aware of the activity around you. Let this awareness work for you.

PERCEPTION SKILLS:

How you perceive others and how others perceive you can significantly stand in the way of your career or significantly help move it along. For our purposes, perception is the initial feeling we get, the first impression we form, of or about someone at our first encounter or experience with them. No matter how strongly someone else might tell you differently about that person, our perceptions, once formed, are difficult if not impossible to change.

If the first time we meet I find you to be pushy, demanding and difficult, that is an impression I am going to carry with me for a long time. I certainly would not be eager for a repeat visit. If, on the other hand, I find you to be warm, friendly and pleasant, you

can bet that is an encounter I will want to repeat. You can imagine how this might play itself out in an audition situation where you are meeting a casting director for the first time, or when you are meeting for the first time with a potential agent or manager.

Yes, you will form an immediate impression of everyone you meet, but remember that they are also forming an immediate impression of *you*. As you read this book, you will discover how to make that impression a positive one, one that works for you as you build your career.

The role this set of skills will play in the positive development of your career will make you a better actor in both the business and the performance of your career. You will see how mastering these skills will help you move ahead with focus, motivation and determination every step of the way. So read on and prepare to learn everything you need to know about the business of acting, and more than a few things about yourself in the process.

THE TRANSITION FROM STUDENT OF THE PERFORMING ARTS TO PROFESSIONAL PERFORMING ARTIST

A s a student of the performing arts, whether you have studied in school or on your own, you must, at some level, *always* be a student of the performing arts. This philosophy requires you to recognize that in order to be your best, you must always be learning something new. When you are not working professionally, you must be engaged in other activities that are positive, helpful and reassuring to your career and to your life. Sometimes it is a class. At other times it is the job that pays your rent until your acting career alone can support you. While I will demonstrate and discuss with you the skills that you need to build the career you want, the actual talent piece of what you bring to the world is for you alone to assess, to grow, to hone and to develop.

Great actors rarely start out that way. Have you ever seen the early films of people who you would now consider stars? They, like you, may have "the gift," and for you, as it was for them, that gift requires careful nurturing and significant opportunity. Your professional life assignment really is twofold: to develop your skills as

a businessperson and to nurture your potential as an actor. There are only two ways to achieve this: experience and training.

When you are not working as an actor or when you are working in a temporary "other" job, it is important to fill your life with activities that will benefit you as an actor. There are a wide variety of good, effective classes in Los Angeles, New York and places in between that will give you opportunities to broaden the scope of what you can do. They can help you develop new techniques and enhance what you already know. You can take lots of academic classes and read lots of books about what it is like to be an actor, but there is nothing that will teach you better than by getting out there with both feet and experiencing it for yourself.

Often it is the thought of beginning this experience that is the source of the greatest invigoration and the greatest fright for the student of the performing arts who is making the transition to professional performing artist. It is like that first dive into a swimming pool or your first bungee jump (so I'm told)—exhilarating and scary at the same time.

I am thrilled that you have this book. As you read through each chapter, you will learn how to develop and implement the skills you will need for successfully conquering the tasks of the business. As a part of the process, it is also important for you to get out there and immerse yourself in the daily activities of life as a professional actor and experience how it all feels.

Transitions can be difficult to make for all of us at one time or another. But as your life and the world around you keep changing, your ability to adapt will often be called upon. From one show to another, from one set of colleagues to another, from one class to another, your life as an actor will be filled with tremendous highs and exciting challenges. If you can learn how to turn the down times into positive, constructive periods for yourself,

you can avoid the "I'll never work again" blues. If you can involve yourself with projects and activities that will turn your non-acting time into opportunities for you to further develop your career and your craft, you will always look at these down times as a gift, not a scourge.

I often see in college students and in recent graduates some behavior that frustrates me. Mostly, it is the result of the environment in which they have just spent four years (or more) of their lives.

When you are in college, your goal is to get your degree. You work as hard as you can to get through classes, exams and professors who might not always be as supportive as you would hope. Finally, graduation happens. There you are, in your cap and gown, holding the diploma you have struggled to earn and closely surrounded by school loans that you will soon have to begin repaying. What's next?

That diploma is very symbolic for most graduates. Most students believe that with that piece of sheepskin in their hands, the long days and the grueling hours of study are behind them. That mindset could not be further from the truth. The truth is that the hardest work you will ever do is still ahead of you. If a successful career as an actor is really what you want, as in any profession, you will work harder to achieve that success and to maintain it than you ever did to earn your diploma.

Acting students often feel ready and ripe as soon as they have finished school. They want to hit the pavement running and begin their careers right away. If this is you, this is where the road show that will become the journey of your career can first begin to get in trouble.

It's easy to get a skewed view of the outside professional world when you are a student in any college or university class. Mostly,

you know what you know because you have learned it in an academic, classroom environment, from field research or from the collegiate theatre experience—and that is exactly what college is meant to provide you, all of that initial introduction and exposure, from the ground up. However, you have also been, by the nature of the experience, insulated within this community. Unfortunately, that environment is rarely an accurate reflection of life in the professional world.

You may have had the chance to audition for college or university productions. If you were a performing arts or related-major student, no doubt you were required to audition for and/or appear in many of these productions. Maybe you had the chance to audition for or play the role of the elder Aunt Eller in the school's production of "Oklahoma" or Tevye in "Fiddler on the Roof." That will stop after you leave college, and those experiences are at the roots of what I call actor entitlement.

Different actors display this sense of entitlement in different ways. Sometimes it is in an attitude that reads that you think you have already proven your talents through work you have already done. It is an attitude that reads that you think you already know everything you need to know. At other times it is reflected in your own frustration that your career is not moving ahead as rapidly as you think it should. Maybe you think you have already paid your dues.

If this is you, stop thinking and get a grip on where you are right now in your career before you cause yourself tremendous emotional trauma. The day when any of us knows everything about our professions will never come, nor should it. There is *always* something new to learn and someone new to learn from. In order to grow, you must recognize that progress equates with growth, and growth equates with learning. You would not want

your doctor to stop acquiring new information just because he or she is through with medical school. You shouldn't either.

Maybe this is not you at all. But I bet you know someone to whom this applies. A sense of entitlement, if you have it, will work against you at every turn—but it may not be entirely your fault. Schools, classes, instructors can all contribute to why you might have come away with this attitude. After all, if you have been convinced that you are a star back home, why wouldn't the professional world see you as a star, too?

In the real world, the world away from the safe haven of college and classes and community theatre, there are real 60-year olds who will audition to play the role of Aunt Eller or Tevye. This is not meant to demean or lessen the importance of playing these roles when you can in nonprofessional venues. However, as a 20-year old in the professional world, you would never get that chance. This is just one example.

You must make an honest, objective evaluation of where you fall in the mix of roles you can realistically play. How old are you, really? What is the age range you can realistically play *now*? What are some of the unique characteristics that set you apart from other actors and roles they can play? Are you of a nationality or ethnicity that makes you eligible for culturally sensitive casting? Do you speak a language other than English well enough to qualify you to play this range of roles in professional American and non-American productions? Your answers to these questions will ground you in what will be the truth, not the entitlement, of your career.

Actor entitlement can get in the way of your professional growth. It can foster an attitude that will not serve you, your journey or your career well. Sorry, but you are not entitled to play whatever role you want just because you think you can play it.

You are not entitled to access and opportunity simply because you have a college degree and think it is owed to you. It is not. Actor entitlement will get you in trouble. Self-awareness and hard work will earn you the access and opportunities you desire. They will also lead you to the next logical step on your career journey, if you patiently let them.

The self-evaluation process is crucial in your transition from student of the performing arts to professional performing artist. It does not matter at what age you make this transition. Maybe it is not a transition from school. Maybe it is a transition from one career to another. What matters is that, whether you are transitioning at 22 or 42, you think about who you are and where you realistically want to be, and that your business plan reflects the results of this self-examination.

That you were once the star of the school's musicals does not mean much to a professional casting director in terms of credits. But your training, along with the experience and exposure you gained from doing it, certainly does matter. Because you were a star in high school or college is not reason enough to cast you into a series lead role two weeks after graduation, although I have met many young actors who have disagreed. It is a tough realization in the transition for a lot of students who have achieved notoriety while at school.

I admit that the humbling part of the transition can be painful. But it is also extremely necessary. It is one thing to know you have talent that matters and is meaningful. It is another thing to behave that way. Let your previous experience show through in your preparation and your auditions for professional projects. Your ability to have a level of comfort in an audition situation or on a stage that is the result of your having appeared in college and/or other local productions will work in your favor, if you let it.

It may sound like I am asking you to completely start over, but I am not. Look at this new perspective you will have on yourself as the result of the first of many such self-evaluations you should undertake throughout your professional career. Start by cleaning your emotional house a bit. Take stock of what you have. Keep what can be helpful to you along the way and throw out the rest.

You will meet a lot of interesting people along your journey. Most you will really like. Some you will loathe. It is important to learn how to properly process the professional experiences you will have in the business. I wish I could tell you that all casting directors are wonderful, that all agents are great people and that all managers are supportive. I cannot say that. But I can say that most are. Remember, sometimes initial perceptions can be misleading, especially negative ones. Don't let a sense of entitlement or your own perceptions stand in the way of the positive experiences that await you in the development of your career.

One of the most important skills you will need to develop in your transition is the ability to hear and see things only in terms of black and white, instead of in the vibrant colors that actors tend to paint onto and into most of their experiences.

It is important to look at things the way they really are, objectively, not the way you may emotionally spin them. This applies to your interactions with people, too. For example, your default should not be to assume that a certain casting director hated you because he (or she) was not terribly friendly to you at an audition. Perhaps that is just the way he operates when he does business. Unless you have previously given someone a reason to dislike you, do not take what you perceive to be his or her negative behavior toward you personally. It is not that the casting director liked you or did not like you, or that you are too fat or too thin or too short or too tall, that will or will not get you the part. Sometimes,

perhaps most times, it will just be that they hired someone else. Black and white. We'll revisit this philosophy in Chapter 9: Emotional, Physical & Fiscal Fitness for Actors.

When I call a casting director to follow up on how a client's audition went, the answer I hear most often (which is the answer I hate the most) is "They went another way." They went another way? What does that mean? I am not even sure *they* know.

So while my client may have been liked or disliked, too fat or too thin, too short or too tall, ultimately it is not about any of those things that really matter. They either get the job or they do not. Period. Black and white. It would do them no good to beat themselves up over it. Given that "they went another way," there is nothing the actor could have done that would have made any difference. There rarely is. However, the audition process is not just about getting a part (or not), and it is in this overall process where you *can* impact the result. You will read about how to accomplish that in Chapter 4: A Casting Director's Perspective.

Successful transition is the result of successful focus. Do not rush your transition. Let it happen. Learn from every incident, accident and happy discovery along the way.

I talk a lot about one's journey because your career needs to be in constant movement, always a work in progress. Seeing it as a journey will prevent you from just running in place and ever feeling as though you are stuck. Looking at your career development as a journey will always keep you in forward movement. That is why your business plan is crucial. Like a road map, it will help get you where you are going, regardless of the rest stops you take along the way.

Learn to use what you know from the past to help you mold and plan your future. Learn to trust your judgment. Never doubt

your faith in your ability to succeed. Remember to take those occasional, but regular, rest stops for some self-awareness, reflection and personal evaluation.

Take care of business and the rest will fall into place, in its own time, not yours. Transition yourself by being prepared to handle whatever is around the corner next. Learn to recognize and value the small successes you will achieve each day along your career journey.

ONE STEP AT A TIME:

Create Your Own Personal Business Plan for Motivation, Focus and Success

FROM MY ROLE as a manager of talent, a PR specialist and a college faculty member, I have developed a passion for teaching students of the performing arts, of any age, how to transition themselves into career performing artists. Sometimes it is a first time out. At other times it is a fresh start for a stalled career. I have discovered that regardless of where you are on your own career path, there are certain skills that all actors need to develop to put themselves on the road to success and then to stay there.

In the beginning, you are on your own. It is up to you to do the work that will lead you to the opportunity. Later, others will do some of that work for you, but ultimately this "work" is a process that needs to be ongoing, always, by you.

You need to be keenly aware, right from the start, that the business of show business necessitates the realization and the acceptance that you are a business unto yourself. The sooner you accept and assimilate this concept, the sooner three key things will happen to you:

✦ First, you will stop taking rejection personally (it is your product they have chosen to pass on, not you personally);

✦ Second, you will start looking at your acting talent as a service you provide to the entertainment community;

✦ And third, you will begin to look at promoting the growth of your career as you would any product you might have created and want to sell more of.

The important tool every actor needs to implement this strategy for success is the same critical tool any other business needs in order to succeed: a business plan.

As an actor, you need to create a personal and objective plan of attack, detailing the steps you will take to launch, or relaunch, and then to maintain your career. The acting business is an industry where success has little to do with talent, training, education or credentials. Success in this business has *everything* to do with opportunity, timing and an actor's readiness to assume the tasks assigned. It is a balance between goals and tasks: goals to set and tasks to attain those goals.

I tell both my clients and my students that a personal business plan is essential. It will give you focus. It will give you motivation. It will give you objectivity. Your business plan will contain key elements to keep you on track.

Your personal business plan should include a week-by-week breakdown of what you intend to accomplish each particular week for a given period of time. You are even allowed to schedule time off, lunches and trips to the gym, the movies and Starbucks. Be specific. Write it down and hold yourself to it. You must make your assignments commitments to yourself.

To start, it is important to forget that you have done anything

previously to promote your career. Start from scratch. You have a clean slate on which to create and establish primary, achievable goals for yourself, goals that you alone are capable of reaching on your own.

For example, your goal should *not* be to get an acting job that pays you money by March 1st. It is impossible for you to guarantee yourself that you will meet this goal through any means that you alone can create and implement. Your primary goal (getting an acting opportunity) should be to carry out the steps that can lead you to this secondary goal (getting paid for it). Business plans are about *primary* goals. While you cannot guarantee that a specific paying job will be yours by March 1st, you can guarantee that you will do all that is within your power to get yourself on track for it. Take care of your primary goals and the rest will fall into place.

The steps of your personal business plan should include personal assignments like these, spread out into three phases of business pro-activity, covering periods of three months each. Phase I focuses on certain tasks. Phase II focuses on other tasks. Phase III focuses on a little bit of everything, as needed. As you will see, some tasks need to be carried over from week to week, but others will be more periodic.

Your personal business plan might look something like this:

PHASE I GOALS:

1. New head shots.
2. Seek opportunities to act in student films.
3. Review (and revise?) my resume.
4. Research showcase opportunities.
5. Research information for agent and casting director mailing lists.

6. Draft submission pitch letter.

7. Become consistent at reading trades and related sources.

Phase I Tasks:

Week 1:

1. In preparation for pilot season, start looking at friends' head shots. Call the photographers who took the head shots that I like and find out how much they charge for a session and what the session fee includes. Ask if their fees are negotiable. What if I shoot only one roll of film? Would it be less? After all, it only takes one frame. Schedule a session for next week, if possible.

2. Do I have *appropriate* film or tape on myself to assemble a demo reel? If not, I must set out to do enough student films and other taped/filmed projects over the next few months to get this kind of footage to achieve this goal.

3. Work on my resume. What does it look like? Is it in a good, easily readable format? Is it truthful? Ask friends to see their resumes. Are any of theirs styled in a way that looks better to me than the way my own resume is formatted?

4. Make sure my answering machine or voice mail system is working properly. Is the outgoing message professional and appropriate?

Week 2:

1. Research showcases to participate in prior to pilot season. Ask friends about what showcases they have attended and liked.

2. Use the Internet to research other resources and compile a list of these useful sites to return to.

3. Start assembling mailing lists of appropriate agents, managers and casting directors to send new head shots to.

4. Start working on the pitch letters to be sent with the new head shots. Research the costs of assembling a short video demo.

WEEK 3:

1. More research in preparation for my mailings.

2. Call every targeted person to see if they are accepting personal submissions for representation and/or informational interviews.

3. Do I have the spelling of their names and their addresses correct?

WEEK 4:

1. If new photos are ready, implement mailing, keeping track of where every photo goes.

2. Plan a schedule of telephone follow-up for next week.

EVERY WEEK:

1. Read the trades (Daily Variety, Weekly Variety and Hollywood Reporter) regularly to keep up on the business of the business and on who is doing what. (Note: It is not necessary to personally subscribe to these publications; they are available at many libraries. Limited access is also available on these publications' Web sites. See Chapter 14: Helpful Web Sites, Online Services & Other Resources for Actors for details.)

2. Read other resources and publications religiously, every week, like Back Stage (East Coast) or Back Stage West (West Coast), to stay informed about industry news and casting

opportunities. Check their Web sites (see Chapter 14).

3. Read casting notices, every one, every week. Submit myself for everything I think I am right for, particularly college and university student films.

4. Scan my other resources, including other online services, for information that might be helpful or useful to me (see Chapter 14).

This plan would continue for subsequent weeks, months and phases. There would be and should be repeated tasks for you to do in upcoming weeks. This is a cyclical process. You are a work in progress and so, too, are your business plan and your career.

You certainly would not have new pictures taken every month, but you would repeat a lot of the other tasks that make sense for you to repeat. This is not a test. You will not be graded. There is no wrong answer. There are only positive steps ahead. It has to be a plan that you can not just live with, but live *on*.

Now that you have seen the start of a sample business plan, here is a worksheet for you to use to begin creating Phase I of your own business plan. Start by setting five to ten realistic goals for yourself. What do you want to accomplish from the implementation of Phase I? First write these goals down; then plan the tasks and activities that you will undertake each week to achieve them. Start listing the activities you plan to include in your weekly routine.

Phase I Goals:

1. _____

2. _____

3. _____

4. _____

5. _____

6. _____

7. _____

8. _____

9. _____

10. _____

Phase I Tasks:

Week 1:

1. _____

2. _____

3. _____

4. _____

5. _____

Week 2:

1. _____

2. _____

3. _____

4. _____

5. _____

Week 3:

1. _____

2. _____

3. _____

4. _____

5. _____

Week 4:

1. _____

2. _____

3. _____

4. _____

5. _____

Every week:

1. _____

2. _____

3. _____

4. _____

5. _____

I strongly recommend that you keep a notebook or start a database where you can create and maintain separate work-in-progress lists. Categories should include new contacts made, new contacts to pursue, other leads to follow up on, tasks accomplished and potential new tasks to undertake as a result of your new contacts.

Here's a format I have found helpful for these listings:

New Contact Information:

Date: ————— Name: ——————————

Title: ———————————————————

Address: ———————————————————

Telephone/fax/e-mail: ———————————

Notes from the conversation: ———————

———————————————————————

———————————————————————

New tasks as a result of the conversation: ———

———————————————————————

———————————————————————

———————————————————————

New leads to follow up: ———————————

———————————————————————

———————————————————————

———————————————————————

Tasks completed: ———————————————

———————————————————————

———————————————————————

———————————————————————

———————————————————————

Keeping a running tally of the things you actually accomplish as you accomplish them can be very beneficial to you. While the responses you get from some of your outreach activities may be less than you had hoped for or anticipated, you should nonetheless recognize your achievements in having implemented them.

Writing out your business plan will help you accomplish your mission. Making and keeping notes on the entire process as you go along will become invaluable. Who did you talk with? What was the assistant's name? Did a friend mention a lead worth following up? Have you uncovered information that would be helpful to someone else? Share your resources. Be supportive of your fellow actors, not competitive against them. Do not foster negative energy. I believe that you will always get what is yours to get.

This is a business in constant movement. Movers, shakers, players and those on the journey there have roles that can change at a moment's notice. Be aware. Keep tabs on people you target for contact. Even if you cannot get through to them at first, you will eventually. The more knowledgeable you are about them and about the work they do, the more impressed they will be about you and about the work you can do. We will explore this further in Chapter 11: Publicity, Marketing & PR for Actors.

Those who become successful learn how to become savvy players themselves in the process. Knowing how to be proactive, and how to straddle the fine line between assertiveness and obnoxiousness, can make the critical difference between who gets the access, who gets the attention and, ultimately, who gets the opportunity. You will notice that I said *opportunity*, not job. *Anyone* can get a job, but it takes real skill and real talent to create opportunities to open up to you and for you.

Like you, every business plan is an individual creation. It should

reflect your greatest career aspirations and how you intend to get there. Every business plan also needs to be realistic, affordable to implement and full of ideas that will translate into your personal road map to success.

Put it in writing and let your journey begin.

THE BUSINESS OF TALENT REPRESENTATION:

Navigating the Muddy Waters of Association

IT'S TRUE, there's no business like show business. It is also true that there are no people like the people in the business of show business. This can be a positive and a negative, and sometimes both at the same time. The key word to remember about the business of talent representation as I lead you through these muddy waters of association is the word "business" itself. Show business, like any other business, needs an economic base to survive and prosper. It may be the business of talent and entertainment, but if the economics of running one of these businesses is not priority one, there can be no "show."

There is great risk in any business operation today. In the real world, you need to offer a great product, you need to offer great service and you need to offer great value. The same holds true in the business of talent. However, unlike in most other businesses where your product defines your business, in talent representation it is the agents and managers themselves who define the kind of businesses they have, the kind of products they offer and the values they can provide through the actors they represent.

A look at the business of talent representation and how it operates presents some interesting options and prospects for actors. We will take a look at the two sets of players involved: managers and agents. To understand what each really does, what each is supposed to do and whether one or both kinds of representation are right for you, you first have to understand the process itself.

The entire business of talent representation is undergoing tremendous challenge and potential change right now. It has been an evolution, a revolution to some, that has been brewing for years. It concerns both agents and managers and the scope of the services they can provide and the dollars they can earn. This movement is the result of the state of the industry as well as the influence of the actors' unions on the business of talent representation.

The California State Senate Select Committee on Regulation of Talent Agents was created in April 2001 by the California Senate Rules Committee. It was directed to study "all issues related and ancillary to the representation of artists by talent agents and managers." The creation of the Select Committee resulted from a stall in the ongoing negotiations between the Screen Actors Guild and the Association of Talent Agents about proposed changes to the public and private rules of regulation for the industry.

The unions want to protect the interests of their actor members. Talent agents want to protect and grow their businesses. We managers want to be recognized and respected for the influential roles we play in our client's careers.

How to accomplish these goals without creating a conflict of interest between agents, managers and actors is at the core of the unions' issues. At that core are two key questions: whether or not to grant talent agents the freedom to expand their jurisdiction into other areas of the business; and whether managers, who are

not regulated in any way, should be held accountable for their business practices as agents are.

Managers generally want no part of the kind of the regulations the unions are seeking. This does not, however, mean that we are completely opposed to some kind of system of regulation that works for us and with us, not against us.

Currently, by official definition, managers are not supposed to seek or procure work for their clients. That's the rule, but most will do just that anyway, especially if a client has no agency representation or is underrepresented or ignored by his or her agent.

The Screen Actors Guild is not disputing the importance of a manager's role in an actor's career, but is objecting to the manager's scope of authority. The guild contends that managers can do all the advising, counseling and developing of talent that we care to do (which has always been our area of jurisdiction), but once we step over the line to procure work and negotiate contracts for our clients, SAG believes that we then become, by definition, talent agents and should be required to have a talent agency license and be so sanctioned by the unions.

There is a financial bond that all talent agencies must post to operate their businesses. Managers, being unregulated, do not have this requirement to fulfill. The unions are attempting to have any agency or person who procures work for union members be required to be sanctioned by them, licensed by the state or states where they operate and secure this bond.

It is a highly controversial subject in the Los Angeles actors/agents/managers community now, with a potential for a wide range of repercussions that could affect the way business is conducted and how actors are represented from L.A. to New York.

Pending legislation in California may bring some order to the mayhem. While many of the current rules and regulations in New

York State are similar to those in California, any changes in regulations in California are bound to provoke discussion and argument for similar changes in New York, as well. Because California and New York have the largest concentration of talent representatives, you can expect that any new legislation or changes as to how business is done will ultimately come from either or both of these states.

Complicating matters is a yet-to-be-addressed factor. None of these discussions or proposed changes addresses the needs of the nonunion actor. To the unions, if you are not one of their members, then you are really not an actor at all. This leaves an enormous population of actors in Los Angeles, New York and elsewhere around the country whose voices are not being heard. They deserve protection as well, but it is apparent that any discussion about nonunion talent will have to be had between agents, managers and their nonunion clients. Added to the mix is that SAG-franchised agencies are not even supposed to represent nonunion talent. Yet some, if not many, do so anyway. We'll explore this further in Chapter 8: Unions & Actors.

I attended a daylong hearing of the California State Senate Select Committee held in Los Angeles in late 2001. Lots of testimony was presented, some of it about the need for change, some of it in defense of the status quo; there was little agreement on anything. The committee issued an opinion in October 2001 supporting the position of the Screen Actors Guild that talent agents should not be able to expand the scope of their businesses into areas that might pose potential conflicts for their actor clients. The committee said little else from a hearing that occupied a full business day.

What any or all of this will mean for you will depend, of course, on what happens next in the agents' contract negotiations with SAG, any further recommendations made by the Select Committee and/or any other actions pursued by the unions regarding regulation of managers. If your base is or will be New York, changes there will depend on how any changes shake down in the process of their implementation in California.

We shall see whether this will mean, in the long run, that managers will be regulated. Only time will tell whether the scope of other business activities agents are allowed to engage in will change. Whether this means it will become more difficult for you to get representation also remains to be seen. Regardless, what will *not* change are your personal responsibilities in the process of seeking representation. We will focus more on this in Chapter 11: Publicity, Marketing & PR for Actors.

If anything, the exploration and discussion of these issues help drive home the need for you to stay in the loop of information about the business. Bookmark the SAG, AFTRA, Daily Variety and Hollywood Reporter Web sites (see Chapter 14: Helpful Web Sites, Online Services and Other Resources for Actors) and refer to them regularly to keep on top of news and developments on this and other actor-related issues. You will also find regular updates and revisions to the information in this book at *www.thebusinessofacting.com*, so be sure to bookmark that site as well.

Barring any significant restructuring of the system, which is doubtful, let's look at the backbones of how talent management and talent agencies work—and how they differ.

A good talent manager can make a, if not *the*, significant difference in the development, growth and maintenance of an actor's

career. A bad manager, like a bad agent, can kill off or at the very least slow down an actor's chances for opportunity.

Most legitimate, professional managers are people who nurture by nature. Our professional and oftentimes even personal mission is not just to develop talent but to nurture it. It is not only new, young actors who benefit from this. Many seasoned actors have enjoyed the benefits of this career assistance throughout various stages of their working lives.

The key words here are "legitimate" and "professional." Because talent managers, unlike talent agents, are not regulated, there is, unfortunately, room for the unscrupulous to settle in. Currently, all it takes to become a talent manager is the desire to do so, a shingle for your door, some business cards and letterhead. Regulation of managers could change this significantly. But as long as managers remain unregulated, you must become as skilled and knowledgeable about the business as you can to avoid the "manager" who is not really a manager at all. You do not want to become a vulnerable, naïve and desperate actor who could easily become attached to a manager who might not be acting in the best interests of your career.

How do you keep this scenario from happening to you? There are some black-and-white truths that you need to know:

1. Legitimate managers will *never* sell you acting classes, workshops or coaching sessions, although we may *recommend* some of these options to you.
2. Legitimate managers will *never* refer you to classes or workshops that, or coaches whom, we have any financial interest in. Many managers will work with you (at no charge) in preparation for an audition as a part of the overall services we provide. It is in our mutual interest for you to always be the best you can be.

3. Legitimate managers will *never* sell you photography packages, although we may (and probably will) *recommend* photographers to you.
4. Legitimate managers will *never* refer you to a photographer in whose business we have any financial interest.
5. Legitimate managers will *never* sell you *anything*. Legitimate managers will only offer you services that you will pay for based on a percentage of what you actually earn (more about this shortly).

If you sign a contract for representation by a manager, you have potentially signed yourself up for a legal relationship that will usually hold up in court. Some of these contracts can have stated terms of representation long enough to make your professional and personal life miserable if the relationship does not work out. You can also find yourself financially committed where you do not want to be, as well as short on the opportunities your manager led you to believe he or she would generate for you.

If this sounds like a scary scenario, it can be. Unfortunately, it happens often to the unsuspecting, uneducated actor who dreams of becoming a star. Upholding ethics in business is a goal for all legitimate businesspeople. Compromising ethical standards is, unfortunately, a routine practice by the unscrupulous in all kinds of businesses, ranging from show business to roofing to auto repair—and hundreds of other professions in between. It is buyer beware in any open marketplace and that includes the marketplace of talent representation.

One final note about management contracts: It is not unusual for a professional, legitimate talent manager to ask you to enter into a long-term contract with him or her, sometimes two, three or more years. Many managers have such signed agreements with

their clients. Unlike a contract with a franchised talent agency that has a built-in "out clause" (we'll get into that shortly), a generic management contract is a binding agreement with preset terms. That does not mean you cannot or should not attempt to negotiate other terms that better suit your interests and your comfort level. Most managers I know are willing to work with prospective clients to arrive at an agreement that both parties can find protection in and comfort with. If a prospective manager is not interested, willing or open enough to discuss the terms of a potential contract with you, then find another manager.

Like agents, there are good managers and there are bad managers. The good ones work hard to earn and protect their reputations by doing what they agree to do for the clients they sign, and by living by a personal and professional code of ethics that serves both them and their clients well every day and for the long term.

By the way, you might be interested to know that I do not have contracts with any of my management clients. Ultimately, this is a business based on trust all around. They trust that I will do what I agreed to do, and I trust that they will do what they have agreed to do. It is a partnership. I have been surrounded by a group of wonderful clients with whom I share a deep and mutual personal and professional respect. If the day comes when that is no longer true for either of us, then it is time for us to cease working together. Why go through the expense and energy of a court battle to uphold a contract that will, in most cases, pay less in the long run than the cost of the legal battle? Business is business, and how anyone chooses to operate his business must make sense to him in every way. Not having contracts with clients is a choice that works for us.

If managers are eventually regulated, management contracts may be standardized as they are for agents and their clients. Regulating managers might also provide us with the opportunity to

legitimately and openly compete in the same marketplace as agents. This also has many agents worried that they might end up having to compete with managers for clients who would not necessarily need or want both an agent and a manager representing them in a marketplace where both could legally secure work for them. This could mean that one of them has the potential to lose a client, lose a commission and/or perhaps lose the ability to earn a living. In this scenario, your personal and professional needs as an actor would determine which type of representation best served you.

Managers usually have just a few clients they have selected to work closely with. Agents, in most cases, have many, many more clients than managers do. Managers develop the careers of their clients. They also develop close, professional and personal relationships with them. Agents are usually not interested in an actor's personal life (of course, there are exceptions). They are mostly interested in the actor's ability to show up on time and be prepared for any audition they procure. Current regulations limit a talent agent's commission to 10 percent, when you book the job.

On the other hand, most managers do care about the lives of their clients and can often become deeply involved with them while helping them along their career journeys. Legitimate talent management requires a close working relationship. For this more intimate and intensive work, we are usually compensated at a higher commission rate than talent agents. The norm is 15 percent of the talent's gross earnings. I say "the norm" because the commission a client pays his or her manager is often open to negotiation.

This figure could range anywhere from 10 to 20 percent (or more), depending on what other professional services the manager provides to the client and the contract terms initially agreed upon. Any regulated attempt to shrink a manager's commission could

also necessitate a decrease in the amount of time a manager can spend on and with a client. It is a matter of economics.

While the legal accountability of regulation would also quickly put the unscrupulous out of business, it has the potential to inflict financial harm on legitimate managers because of the dollars they might need to pay in support of a new system. It is also important to acknowledge that there are many legitimate managers who have been in business for years, decades, without any client problems or conflicts whatsoever. What do they stand to gain from regulation?

I believe that there is another piece of this discussion, too, one that places most of the burden of this issue on the shoulders of actors. When seeking representation from an agent or a manager, you have to take responsibility for yourself. You are the one who will make the decision about who will represent you. You must be responsible for that decision and for choosing the person or people you believe is/are right for the job.

It is easy for an actor who feels desperate about his or her prospects to fall into a dangerous mode of thinking and behaving. Just because someone offers to represent you does not mean you should let him. You need to do your homework. You need to do your research. Learn what you can about any prospective representative. Learn about his business. Who are his clients? How long has he been in business? Can you talk with some of his current clients? What do these clients have to say about the work that agency or management office does for them? What does your instinct tell you about the potential association?

Most, if not all, talent agencies will want you to sign an initial one-year contract with them. This allows them to legally represent you, to submit you for work and to secure work for you. It also

gives them permission to negotiate how much you will be paid for this work. It binds you to them for one year, with one exception, which I will explain momentarily.

Never sign a contract for more than one year that does not have an out-clause in it for you. Never sign a contract with a talent agency that is not a union-approved or franchise agency contract (although at this writing that contract is subject to changes as the Association of Talent Agencies pushes to renegotiate terms with SAG). While you will be committed to each other in a business relationship for one year, if a talent agency has not secured an audition or a job for you in any 90-day period, the terms of the contract currently allow you to cancel that agreement. I do not expect that there will be any changes to this clause regardless of what other changes may be made.

Every case is a different situation and every career a different entity. I would never advise an actor to walk away from an agent just because there has not been an audition or a job in 90 days. Sometimes there are reasons, but often there are not, for why one actor gets auditions and jobs and another does not. If your agent believes in you and if you believe that he or she is working for you in a positive and productive way, then there is no reason to leave.

If you begin to doubt your agent's commitment to you, then talk with him or her about your concerns. Be proactive about your own career. The worst thing that will happen is that you will discover that while there was once great hope for this business relationship, things have changed. It happens. Know when it is time to move on. Some agents don't like to tell actors that they have lost interest in them. They would rather let an actor's photos sit in a bin and go unused then have that conversation. That happens, too, sometimes.

Here is a clue that something might be up. If your agency has

not called you to replenish your supply of photos and resumes for their files and/or if you have not had an audition secured by your agent in three months or so, that is one indication that it is time for a conversation, so initiate it. Protect your own interests. Be proactive, be professional—and be prepared to move on, if that is what is in your best interest. Sometimes you will learn that it has just been slow in your category. You will never know unless you ask. So ask your questions and then carefully, clearly listen to the responses you get. Never be afraid of your agent or afraid to have a conversation with him or her about your career. Just make sure you pick an appropriate time for that conversation.

You have learned that managers are not supposed to procure work or negotiate the terms of work for their clients, but it still happens every day. It is not uncommon for casting directors to makes deals with talent managers for actors they want to book who have no other representation. Sometimes, even when an actor does have an agent, the casting director prefers to deal with the manager.

A manager may be perceived by the casting director as a person who is not so much a broker for talent at the highest price they can get, but, instead, a person who is out for the best opportunity, not necessarily the best dollars, for their client. I do not want to give you the wrong impression about agents. But I do want you to clearly understand where the differences between agents and managers lie.

Managers seek opportunities; agents seek jobs. Sometimes opportunities become jobs, and at other times jobs turn into opportunities. But the focus, the intent and the approach of the agent and manager in the present system are quite different. A good manager is not going to blow a deal for a client because of dollars. Agents are in business to earn as many 10-percent com-

missions on the highest rates they can negotiate each day. It is the nature of the business. They usually do not have the time that it takes to find, develop or nurture opportunities for a single actor, but there are exceptions. A good manager is always thinking about what is best for a client's career, and usually the money does not come first.

Managers have the same tools available to them as agents for information and leads on castings. Good managers, like good agents, have spent years developing contacts and cultivating relationships with all kinds of people in the business. It is these relationships that can make the difference in how managers or agents use the supplies they have accumulated in their professional tool kits to benefit their clients.

In the situation where a client has both an agent and a manager, the best possible thing they can do is work together, as a team, to make both opportunities and jobs happen for their shared client. When this approach works well, everyone wins. Perhaps the agent knows the casting director on a certain project that offers the perfect role for their mutual client. Perhaps the manager knows the producer or the director of the same project. Together, they can approach the people they know, working in unison, not in competition, to open doors.

That brings me to perhaps the most important part of this entire discussion, the issue of who needs a manager, who needs an agent and who needs both. This is a far better discussion to have now that you know how and why the two differ.

Most young actors believe they need both a manager and an agent, assuming that whomever they can get on their team can help them achieve success. Not true. I think most actors do not need both. Most actors can do quite well with one or the other,

regardless of the changes any future rules and regulations impose.

Nothing beats an actor having a great agent or a great manager. But what makes a great agent or manager for one actor can make a lousy agent or manager for another actor. Great actors do not always have great agents or great managers, either. And nothing beats a great agent or a great manager having a great client—a client who respects what those representatives do and lets them do it, a client who has learned how to be proactive without becoming problematic.

Representation is about relationships at every level. How deep those relationships go is defined by the parameters you set when you are in touch with the realistic expectations you have of your agent and/or manager initially and what you grow to expect from each other.

If you are happy with your agent and you continue to grow in the business of your career in productive and challenging ways, and if you can be self-motivating in the growth of your talent and skills, then perhaps you do not need the guidance and nurturing that a manager can provide. On the other hand, if you are the kind of actor who needs support and encouragement and who wants the benefits and overview that a manager can provide, then it is a manager you should seek.

Only a very few actors really need both a manager and an agent. For only a very few actors are both necessary, appropriate and beneficial.

You really have to assess your own needs. What do you want? What do you need? What kind of support do you thrive on? What kind of attention do you find smothering? Who do you want on your team? Who do you want to work for you and you, in turn, work to benefit them? What seems to present itself as the best of all possibilities to you?

This is not a once-in-a-lifetime personal evaluation. You will go through this process many times throughout your career. Always be as realistic with yourself as you can—and as you expect anyone else to be with you. Be honest and open enough with yourself to see all sides of your situation. Always be fair in your assessment of yourself and others.

You can and will put together the perfect team for yourself, a team to guide you, to nurture you and to lead you to opportunity, even if that team is, in the beginning, a "team" of just one: you. You will learn that you need to be as involved in your career as you expect anyone else to be. You need to be as supportive of yourself as you expect anyone else to be of you. And you need to create and maintain a healthy balance between what you do personally and professionally, what you wish to achieve personally and professionally, and the kind of life you lead personally and professionally.

Remember that you are a work in progress on an incredible personal and professional journey. Enjoy the ride.

A CASTING DIRECTOR'S PERSPECTIVE

PICTURE THIS: You are a casting director and have just been handed a script for an episode of a half-hour comedy series with eight guest roles to cast. The problem is that this is a script for an episode that was not scheduled to be produced for a few more weeks. Yet the producers just changed their minds and have moved it up to be shot next week. You have 48 hours to issue a breakdown, review submissions, set casting appointments, hold auditions, have callbacks, make deals for the actors to be hired and complete the paperwork. I won't say that it happens under the gun like this every day in the office of every major casting director, but it happens often enough. Even for a routine casting job, the process can be hectic. In most cases, it takes a special person to do this job without allowing the stress and pressure to give way to near insanity.

Script changes, show revisions, network requests, producers' demands, directors' visions, agents' requests, actors' behavior—they all have an impact on an ordinary day at the office for a casting director. These people are much more than creative traffic

cops; they are, in many cases, the lifeline of a production.

They can also, however, be perceived as powerful, frightening, unfriendly, rude and uncaring. Notice that I said *perceived,* because while some casting directors are all of those things some of the time and others are some of those things all of the time, most casting directors are pretty decent, friendly, hardworking professionals. Most casting directors have a passion for this business, and are knowledgeable about it, experienced in it and very good at what they do. Unfortunately, the nature of this business is, much of the time, filled with production deadlines and casting desires that could always use a little more time to deliver on.

Most casting directors will tell you that they often just don't have the luxury of a lot of time in which to get it all done. So if they seem brisk or rushed, or if you perceive them as all-business or unfriendly, you might be right. But learn not to take it personally. Usually it has nothing to do with you.

Ultimately, it is not your perception of them that matters. Rather, it is their perception of you that matters most.

For those of you who are new to all this, let me give you a very brief overview of the typical casting process. It generally begins when a script is complete or nearly complete. A breakdown of the script is prepared (this is a listing of all of the characters who appear in that script and some descriptive information such as individual characteristics, age, attitude, etc.). Sometime during that process, the creative team begins conversations with the casting director about who they would like to meet with, audition or offer parts to for the lead roles. They also turn to the casting director for his or her thoughts or suggestions for the guest stars and other roles to be filled. The casting director often comes away from these meetings facing a huge task.

The casting director releases an official breakdown for almost all projects, using an important industry resource called Breakdown Services, Ltd. This is an independent company, which most talent representatives subscribe to, that offers services for casting directors, agents and managers. For a monthly fee, agents and managers receive access to casting and other related information daily. By releasing this information confidentially and only to subscribers, Breakdown Services gets the information about each project directly into the hands and onto the computer screens of the people who will do the submitting to the casting directors.

An important sidebar about confidentiality and access: Where there is information about acting work and actors who want to work, there will be illegitimate use of the information. Sometimes it is an assistant at an agent's office or a manager's assistant who copies the breakdowns and gives them to friends or forwards an electronic file containing the information. They don't take the risk of being caught for free (there is usually some cash that changes hands for providing this information). Sometimes a group of actors form their own bogus management company in an attempt to qualify to receive this information. At other times unscrupulous agents or managers pass along the information to their clients or others for some extra cash. It happens all the time, and it is the bane of Breakdown Services' existence. This illegal practice does not serve anyone well, especially the actors into whose hands the information may fall.

Casting information is not released directly to actors because it would not serve any purpose for the casting director to do so. By releasing this information only to professionals who can meet the needs of casting directors, all parties, especially actors, are served in the best ways possible. On occasion, for a select project, a casting director might approve release of certain casting information

directly to actors through a free section of the Breakdown Services Web site (see Chapter 14: Helpful Web Sites, Online Services & Other Resources for Actors for details).

When a casting director issues a breakdown on a project, she may very well receive 1,000 or more submissions for each role being cast. It is an agent's and a manager's job to responsibly and carefully review casting information and to submit only those clients who are qualified and appropriate for the parts. "Submit with discretion" is a policy I always try to enforce and follow. I think most agents and managers do so the same. I look at it this way: I know my clients. I know what they can do and what they cannot do. I know what roles they should be submitted for and what they should never be submitted for. And even with this discretion from hundreds of agents and managers, a casting director still receives a high volume of submissions for each role to be cast.

Imagine what happens when regular breakdown information gets into actors' hands. They read the breakdown and hurry to submit themselves for everything they think they are right for. The unfortunate key phrase here is "everything *they* think they're right for," not everything they *are* right for. The results of these assumptions are that the piles of envelopes containing submissions pile up even higher in the casting office.

Some actors may have spent significant dollars to get illegal access to this information. They have also taken the time to prepare and send out their materials, as well as having paid postage and supply costs—and, odds are, their personal submissions will never be seen by the casting director, nor will they be seen for the role.

Why? Most casting directors and/or their assistants sort incoming materials into various piles. Talent agencies, most of the time, are separated by size, into A and B (and possibly C) category piles.

Submissions from managers are often separated into a pile of their own. And then, there is the miscellaneous submission pile, which might include managers not familiar to the casting office and actor-generated submissions. In 20 years, I have never known of an actor who self-submitted for a professional project he saw in the breakdowns and got himself an audition as a result. I am not saying it never happens, and I am not saying that some casting directors will not look at those submissions. What I am saying is that, if they do, it is the rare exception and not the rule.

One final, precautionary note on this topic: Breakdown Services' material is copyrighted. It is illegal for those other than subscribers to obtain, copy or distribute this material to others. The company has gotten more aggressive recently in the investigation into and prosecution of people involved in doing so. I can understand why an actor, particularly an actor without representation, would think that access to this information is an immediate solution. It is not. If you have representation, trust that your agent and/or your manager are doing their jobs.

If you are currently without representation and get wind of an opportunity to see or receive breakdowns, do not risk it. Instead of illegally submitting yourself for roles that you probably will not get seen for, spend that energy, time and money on projects that *will* benefit you. Workshops, Equity-waiver theatre, student films, requests for general auditions with a casting director and the professional pursuit of other opportunities will serve you better in the long run.

By the way, submitting yourself for roles you see advertised in publications specifically for actors, such as Back Stage and Back Stage West, is not only okay, it is requested and encouraged. Many times these projects (non-union, student-produced and others) only seek actors through these means.

When you do get your opportunity to audition for a casting director for the first time (if you are new) or for the next time (if you have been at this awhile), I want you to think about four things that matter the most: your preparedness, your attitude, your behavior and your professionalism.

What is preparedness and professionalism? It is being ready for the opportunity. It is having studied the audition materials you were given. It is showing up appropriately dressed, on time, with your 8 x 10 photo in hand with a current resume attached to the back and with a smile on your face. It is about knowing casting director protocol.

When you first enter a casting director's office, it may seem natural to you to walk over to him or her and extend a hand to shake in greeting. Do not do it unless the casting director approaches you first. A simple "hello" and a smile will do just fine. Remember that this casting director has been seeing tons of people all day. Shaking hands and making friends is not on her mind. What *is* on her mind is the hope that you will be so wonderful, so ready, so right for the part that she can rest assured she has found the perfect person for the role.

Casting director protocol is also knowing when to leave the room. When you are finished with your audition, you will know right away if the casting director wants you to run through it again, perhaps to have you try it some other way. She will tell you. Otherwise, I suggest you say something like "Thanks for seeing me" and then leave.

Do not ever try to kiss up to casting directors. "I like your tie," "What a great office," "I'm a big fan of the show you're auditioning me for." Forget it. They have heard it all before. Let them not hear it from you, too.

Your job going into an audition is to achieve two things and

two things only — and neither of them has anything to do with your getting the part. Your number one job is to do the very best you can when you are in there. I tell actors that I never want to hear them say to themselves or to me, "If I only had a chance to do that audition over again, I'd . . ." You should never, ever feel the need to say that. Rather, I want you to honestly be able to say to yourself after leaving any audition that if you had a chance to do it again, you would do *exactly* the same thing you did when you were in that room. That is a healthy and appropriate response that I hope will become your default. That is the end result of preparedness and professionalism.

The second most important thing that I want you to accomplish at an audition is to make a great impression on the casting director. It does not matter if you get the job—if you came in prepared and ready for it. If you are not either of those things, the casting director will remember that, and will likely not look favorably toward you when the opportunity arises to call you in again to audition for a part in another project. But if you are professional and if you do what is expected of you when you are in that room, you will leave an impression that will help your agent or manager get you seen again or more often by this person.

I cannot stress this point enough. Do not bring them candy. Do not bring them flowers. *Do* maintain your focus and your energy at all times.

Some advice about the casting director's waiting room: Never, ever engage in conversations with other actors who are waiting to be seen. It is distracting and rude. And never, ever let how you feel about yourself or the choices you have made in preparation for your audition be influenced or altered in any way by anyone who you see or hear in the waiting room when you arrive or while you

are there. Do not play the "They are better looking than I am" or the "They are thinner than I am" or the "They are on a series and I am not" game with yourself. That is self-destructive.

You do not know what the casting director is really looking for. Sometimes he doesn't even know himself what he is looking for—until he sees it. But remember that he saw something in your picture and on your resume that got his attention and got you called in.

Those of you who are further along are already familiar with what happens next in the casting process. From those people seen for a role, a smaller number (just a few) will be called back to audition again, but this time for the producers and the director. The same rules of protocol apply. Usually, the actor selected to play the part knows if he has gotten the job within the next 24 hours.

If you are not that actor, do not look upon the audition as a loss. You beat out a lot of other people by getting an opportunity to audition, you gave the best audition you could, and you left the casting director with a favorable impression of who you are, not just as an actor but as a person.

That is preparedness, attitude, behavior and professionalism at work to serve you and your career.

THE ART OF THE HEAD SHOT:

A Picture Is Worth a Thousand Words ... and a Career

THE OLD SAYING GOES that a picture is worth a thousand words, and while that adage was not intended to apply to actors' head shots, I cannot think of a better way to help me make a critical point: The issue of perception—how you are perceived by others is never potentially more harmful, or potentially more beneficial to you, than in your photo. Many, many more people will see your head shot than you will ever meet in person—hundreds, thousands, maybe more. How you decide to let the world see you says a lot about who you are and how you feel about your talent, your skills and your potential for success in this business.

I get hundreds of unsolicited head shots a month from actors seeking representation. I wish I could share some of these head shots with you. They would help me make my point quite easily. They are horrible pictures of people who probably are not as horrible as the pictures make them appear. But you never know.

I do not often have the luxury of time to sit, stare and analyze

every photo that is sent in by actors seeking representation. Instead, in just a quick second, I will see enough of the picture to form a perception, a first impression, of the person in the photo. Short as it is, it is enough time for me to make a business decision about him or her.

Agents, managers and casting directors all look at photos quickly and just as quickly form opinions about whether the actor pictured warrants a second, longer look. If not, the photo gets tossed. Whether these initial reactions and responses are fair or accurate is not the issue. The issue is that in just a second someone whose attention you are trying to capture will make a decision about you based on a first impression, not necessarily on reality. How you are instantly perceived makes the critical difference between who gets to the next step with this agent, manager or casting director and who does not. There's a lot riding on this one quick look.

It is *all* about perception. What the image in your photo reveals about you is vital. This image can help open doors to opportunity or it can shut you out—all based on a quick look.

If you send me a photo of yourself that reveals too much skin or too many muscles or overly flaunts some other trait or body part that you deem important for me to notice, you bet I'll notice it. I will notice that one trait that you have decided to magnify, rather than get a general, overall look at what should be the complete, real you. Instead, you will have me stuck on those muscles, that navel, that cleavage, that tattoo. Get the picture?

Too many actors' head shots do not get the attention or the serious consideration that they might deserve from potential agents, managers or casting directors because the actors have forced the recipient to look at them as a particular type, rather than as a real person with potential and intrigue. This says a lot

about how you see yourself, how you feel about yourself and about how you choose to be seen by others. Most actors, if given the opportunity to understand how critical this is, would never choose to send out the images of themselves that they do.

Let me emphasize that I recognize the need to be noticed. Let me also emphasize that getting noticed should be about generating a positive reaction, not an inaccurate, negative response. You want to get recipients to turn over your picture, to look at your resume and then to give you fair consideration for an audition or for a general meeting. Give them that opportunity. Give yourself that opportunity. If you want that meeting, if you want that audition, do not run the risk of not having your talent seen at all because you have chosen a photo that sends the wrong message about who you are. A bad head shot can shut you out of an opportunity.

What makes a great head shot? That's not as easy to answer as what makes a bad one. Your head shot is your calling card, your business card. It is meant to introduce you to a tremendous number of people who may be able to use your service when the right opportunity comes along.

This may sound a bit unnecessary, but it needs to be said anyway: Your head shot should look like *you*, not look like you *think* you should look, but how you really look—with all of your characteristics, all of your expressions, all of your humanity, all of your sincerity.

You should be wearing clothes that are really the clothes you wear in your everyday life, not a new outfit that you might buy for the photo session or an old suit that you haven't worn in years just to achieve "a look." If you haven't lived in the clothes you select to wear for your photo session, a sense of not being com-

fortable in your own skin will come across in your photos.

I know that there are a variety of looks everyone tries to get in a single photo session. I am suggesting that you learn to achieve these looks with an attitude, not an outfit. The essence of any character you will play, like the very essence of you, is not in the clothes you wear but in the person you are. Let that person shine though in your photos.

My friend Robert Kazandjian, a talented and creative photographer, loves his head shot sessions with actors. His advice to ensure a successful session is for you to go to your session ready to play. Robert advises, "Don't come in with your mind made up about what you want your photos to look like." He believes that a large part of each of his sessions is candid. He strongly suggests that you "trust the photographer you have connected with to capture the best moments from your time together."

Another friend, Michael Lamont, is also a talented and inventive head shot photographer who has served as director of photography for several feature films. He reports that the most common problem he encounters with actors is one of self-perception. Michael's advice underscores what Robert says: "When actors come in for a session with their mind already made up about various elements of the shoot, they are setting up both themselves and the photographer for a unsuccessful experience."

Predetermined notions about what you should look like in your new photos, what you should wear, how you should be lighted and how you should pose are not decisions for you to make by yourself. In most cases, they are not decisions you should be involved with making at all. Leave the artistic elements of your session for the photo artist to deal with. Robert and Michael are on the same page with their advice to actors. I could not agree more with both of them.

What makes for a really good head shot? In a word, it is when the photo "pops," when it is striking for all of the right reasons.

How much you pay for your photo session has absolutely nothing to do with the quality of what you will get from it. Any photographer who tells you differently is not a photographer you should be doing business with. Your head shots are about two things: you and your photographer. You have to be comfortable with him or her. They have to be comfortable with you. I repeat, it is not about the money. I have seen actors spend up to $5,000 on a single photo session with a highly reputed photographer only to become so intimidated by that photographer that most of the shots revealed a look of near-fright on their faces. That look could be the result of intimidation or fright—or the realization, half-way through the session, that they actually paid that much money to sit there.

I know a lot of great photographers who charge a variety of fees for the artistic and creative services they provide. My point is that what you pay for your session will not affect the outcome or the quality of your shoot as much as the level of comfort you feel in the presence of the person taking your pictures. It is that level of comfort, not dollars, that makes great pictures. If you have the money and feel comfortable with a higher-priced photographer, then use him or her, but most actors do not have that luxury— and most do not need it.

My other point here is to never, ever have a friend take your photos as a favor or for free. Never have another actor who may also take pictures part time take your photos. Always use a professional photographer whose only business is the business of head shots.

How do you find one of these remarkable artists? Start by look-ing at the head shots of everyone you know and anyone else you can. Ask around. Ask your friends, ask their friends and ask other actors you meet in classes and at auditions (*after* you both have auditioned; remember the advice of Chapter 5!). Do you like what you see in their photos, not just how they look, but how they look like they *feel*? Do they look comfortable? Are their photos pleasant to your eye? Does your eye see the overall photo in gen-eral or something specific in it?

If your eyes go to the eyes of the person in the picture first, it is a great head shot. If your eye goes to an item of clothing, an ear-ring or exposed skin first, then you are looking at a photo that does not serve the subject well.

When you see work you like, get the photographer's name and number. Call and make an appointment to meet. Look at a port-folio of the photographer's work (the good ones will be more than happy to let you have a look; in fact ,they may even insist on it) and discuss prices. Do this with three or four photographers. When all of your criteria have been met, you will have found a comfortable match and a great photographer who is meant to take your head shots.

How much should you spend, really, and what is a reasonable range of prices? I have seen terrific head shots taken by artful, professional photographers who charge in the $250 to $500 range. Be clear on what your session fee buys you. (More about that in a moment.)

Both Michael Lamont and Robert Kazandjian charge session fees that fall within this range. Both are L.A.-based, and both pro-duce work that I admire and respect. They are two top-notch photographers, each with his own unique style and approach to head shot photography. You will find contact information for

them in Chapter 14: Helpful Web Sites, Online Services & Other Resources for Actors.

One photo session should last you a year, as long as you do not do anything significant to change your look after your photos have been taken. Remember, you must look as you look in your head shot all the time—the same general haircut and style, the same weight range, the same overall appearance. I am not saying you cannot change how you look. What I am saying is that if you do change your appearance, then schedule a new photo session. Nothing will damage your opportunity for a job quicker than if a casting director calls you in for an audition based on how you look in your head shot and you come through the door looking like someone else entirely. Do not let that happen, ever.

Something else not to do, ever, at any age, is to airbrush your photos. Let that mole show. Let those life lines show. They are part of the essence of you. Get proper rest the night before your session. Go to bed after lunch if necessary! Too many people, both men and women, have this thing about letting their age show in their photos. Remember: Look how you really look. Be proud of any facial lines and other distinguishing facial characteristics that you were born with or have earned. Let your individuality come through in your head shots.

The session fee you pay for your head shots will generally include the film processing, a set of contact sheets or 4 x 6 proof prints and maybe an 8 x 10 enlargement print or two. Sometimes you can negotiate this with the photographer you choose. Some photographers will give you ownership of the negatives; some will not.

Taking possession of your negatives puts the responsibility on you to make the master prints from which to duplicate your head

shots. It also puts the responsibility for the quality of these prints directly on you. I prefer to have the photographer keep the negatives for one important reason: They will be properly stored to ensure long life, not in a shoebox in a closet or in the corner of a drawer at home that may be subject to heat and humidity.

Your photographer will also then be responsible for giving you the best quality master prints as you request them because he will use a processing lab where he has an established, professional relationship. If a print is not to his satisfaction, he will get it reprinted, usually at no additional cost to you. This process takes advantage of the clout your photographer has with a supplier he regularly does business with.

Should you have one head shot, more than one head shot, one look, more than one look? This is an often-debated question in my office and in class with my students. The answer is … it depends. It depends on your individuality, it depends on the stage of your career right now and it depends on how known or unknown you are.

The answer I arrive at for most actors is one photo, one look. Here's why: A head shot can have a long shelf life. After it has been submitted for consideration for an audition, one of three things will happen with it, to it or from it: It will be put into a pile of actors to be called for an audition, it will be thrown out or it will be filed. If it is filed for future reference, I would much rather see a photo that is a great representation of how you really look kept on file—a pleasing, professional picture with a pleasing, professional attitude.

Any photo of you with a serious or more character-type attitude might have been appropriate for a submission for the specific

role it was intended for. However, for general purposes, if a photo is to linger—and many often do—I prefer it to be one that reflects the actor's more general look.

It is essential to have your name printed on the front (usually bottom, centered, but not always; see the samples that follow) of your head shots. If casting directors only look at the front of your head shot and not at the resume on the back, let them see a great photo and then let them see your name along with it. We will talk about resumes in Chapter 7: The Art of an Actor's Resume & Bio.

Who should pick your photo? Not you, never. Let me make that clear. You alone should never pick your own head shot. Why? You see yourself differently, much differently, than how others see you. We all do. Here is that perception thing again. We usually perceive ourselves differently than how others perceive us. That is just how it is. That is human nature. Therefore, show your proofs to a few people who you like and know you well. Ask them if there is a shot from your session that reflects who you are to *them*.

Photographers will usually make a few selections and suggestions of their own based on the overall composition of the shot. But they do not know you the way your closest friends know you, so ask around. Maybe there is not a single shot from the roll that works. It can happen, but it usually does not. Generally speaking, if you can get just one appropriate photo from a session, that will have made it a successful session. While you should not choose your own photo, you must be comfortable with the choice or choices suggested by others and the selection or selections ultimately made.

For theatrical purposes (for television, film and stage submis-

sions), all an agent or manager really needs is your perfect acting resume on the back of your perfect head shot. On the other hand, the commercial casting business has gone through some changes with regard to client photo expectations and needs. Commercial agents and commercial casting directors used to prefer that actors have not just one single head shot, but a composite shot—four smaller pictures on one 8 x 10 showing the actor in a variety of posed situations with a variety of looks. It used to be thought that this showed the actor's range of diversity. It served its purpose at the time, but I am thrilled that the need for composites has pretty much ceased for all but the commercial print business.

Once you have the master print of your perfect head shot in your hot hands, take it to a processing lab that specializes in duplicating head shots for actors. There are two popular types of processing used for photo reproductions: prints and lithographs. The quality of photo prints is generally better than that of lithos, but the cost is higher.

Lithos, which are photos printed on a paper stock with a series of dots (much like a photo printed in a newspaper), have come a long way in the digital age of photography and reproduction. I have seen some lithos that were as close to the original quality as you can get, but not all litho prints are created equally. The lab that produces your reproductions is the key to ensuring the quality of your prints. As with photographers, you can visit the front office of any legitimate photo lab and ask to see samples of its work.

After taking the time to carefully research and find the best photographer to take your head shots and after spending your hard-earned dollars on the session, you deserve to have your perfect shot seen by others the way it was meant to be seen by the person who took it. By the way, many photographers I have asked

about digital cameras have told me that they prefer film to digital because of the greater control film shoots give them over the key artistic elements of a session—for now.

It is critical to monitor the quality of your reproductions. There are many good photo labs around. Do some research. In addition to looking at some labs' sample photos, ask your actor friends where they go for their reproductions. Are they happy with the quality of the prints they get back? Get a recommendation from your photographer about which lab he or she uses. Three good labs in Los Angeles are Producers & Quantity Photos and Isgo Lepejian Custom Photo Lab for photo prints and Mario Custom Print Shop for lithos. You will find their contact information in Chapter 14: Helpful Web Sites, Online Services & Other Resources for Actors.

You will want to be sure to have your name printed along the bottom of your photos. It is a process called "stripping." You will get to select a font for that type. Keep it simple, crisp and easy for others to read. Use upper and lower case. Follow the lab technician's suggestion on font size (usually 24 point). You should also plan on ordering your new photos in duplicate batches of at least 100. The prices are better with this kind of bulk purchase and, as you will soon see, you will start going through your supply pretty quickly.

Whatever the lab you choose, in just a few days you will retrieve your single most significant tool in your career as an actor: your perfect head shot.

Here are some samples of head shots I really love and why:

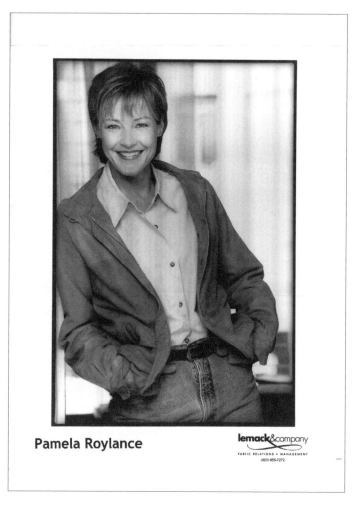

Pamela Roylance

lemack&company
PUBLIC RELATIONS • MANAGEMENT
(323) 665-7272

PAMELA ROYLANCE

I love this photo of Pamela, taken by Robert Kazandjian, because it captures her personality completely. It is casual, it is comfortable and she looks like the kind of person I would like to know. She is very at ease in this picture. To a casting director flipping through piles of photos, I think this one has an energy about it that gets a second look.

William V. Hickey

WILLIAM V. HICKEY

William exudes confidence in his head shot, taken by Michael Lamont. Although he has only recently made his transition from student of the performing arts to professional performing artist, he looks right at home on camera. From the look of his photo, he can play a wide age range in the young adult category, where there is always a huge demand for good actors.

Allison Beal

ALLISON BEAL

Allison's photo is a stunning shot of an attractive young woman who exudes poise and depth of character. I am attracted to this photo for a variety of reasons. Although she is not smiling, as most actors are in their generic photos, Allison has made an interesting choice with her selection of this head shot. She has made a connection with the camera that will draw the viewer into her photo. I like the honesty of this shot. Taken by Robert Kazandjian, it pops in a very special way.

Louis Goldberg

LOUIS GOLDBERG

Some actors defy convention, and this is true for Louis. He is a
young actor whose talent is packaged with a high-energy person-
ality, and this triple-play photo, from his session with Robert
Kazandjian, captures his essence perfectly. Sometimes one photo
alone is not enough, and submitting more than one 8 x 10 photo
for an audition is not usually done. This treatment solves that
problem and covers all the bases. It is still one 8 x 10 shot, but it
is creatively assembled and presented to showcase the range of his
personality.

Jeni4 Jones

JENI4 JONES

It's not a typo or misprint—that is her name. When Jeni4 and I looked at the proof prints from her session with Robert Kazandjian, it was clear that she had a lot of usable photos to work with. A recent college graduate at the beginning of her professional career journey, it quickly became clear that a single shot would not do her justice either. While one photo works perfectly for most actors, others can create a perfectly balanced presentation with creative treatment of their photos. I love the playfulness of this 8 x 10.

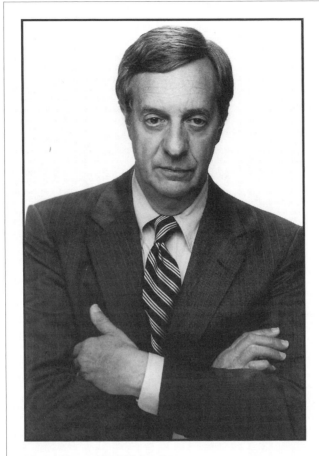

BASIL HOFFMAN

Basil Hoffman

Basil is one of the industry's finest character actors. His photo, taken by Dave Segal, exudes confidence, power and success. The composition of this photo is perfect. What he is wearing compliments his look without overwhelming it, and his strong attitude commands your attention and almost dares you to pick up his photo for a closer look.

Laura Bryan Birn

lemack&company
PUBLIC RELATIONS • MANAGEMENT
(310) 659-6300

LAURA BRYAN BIRN

Laura has had a home on "The Young and the Restless" for more than 12 years. Her photo beautifully captures her fun-loving personality. Her eyes really pop in her picture. She looks comfortable, secure and as if she had a great time at her session. There is an energy about her head shot, taken by Michael Lamont, that makes it a standout.

Adam Briggs

ADAM BRIGGS

This shot, from Robert Kazandjian, is from Adam's first professional session. I really like the composition of this picture. His stance, his body language, his attitude and the composition of the shot all come together in a wonderful presentation that perfectly captures him. This is the result of terrific actor-and-photographer teamwork. This photo is effective and generic enough to stand on its own and serve all submission purposes, from comedy to drama, for film, television and stage.

Ned Wertimer

NED WERTIMER

I love this photo of Ned. In his doorman uniform, he is instantly recognized as Ralph from the hit television series "The Jeffersons." In real life, Ned is a versatile character actor with a wide range of roles under his belt and others still to play. There is no doubt that Ned had a great time at his session. His eyes sparkle, his face glows and his body language is expressive. Photographer Dave Segal captured a warmth here that really draws you into the shot. It works exceptionally well.

So what makes a really effective head shot? It has to have life to it and in it. It has to be a true reflection of you, because it *is* you. It has to "pop" and say "notice me!" for all the right reasons.

Let who you are shine through in your photos, and they will open doors for you to the opportunities you seek.

THE ART OF AN ACTOR'S RESUME & BIO

THERE IS A FINE ART to creating a great resume and bio. Mostly, I see resumes and bios that are not very well written, are not very well thought out and usually have degrees of untruths to them. Let's get into each separately and take a look.

RESUMES:

My students occasionally complain that I hold everyone to the same standard. I am not sure why that is wrong, but in the area of resume and bio writing, I think they mean that I would like to see all resumes and bios have the same uniform look. Of course, my standard for how I like things to look is probably as different as there are people with opinions on the subject. So please take the advice I am about to serve up as some pointers for professional presentation of yourself and your experience on paper and not the way you must do it exactly. Although, as I tell my students, exactly would be nice.

CREATING YOUR RESUME:

An actor's resume has much the same objective and purpose as any other resume you would create to attract the attention of a prospective employer, but in this case it is an agent, a manager or a casting director.

On your acting resume, you want to leave out the "responsible for" and "spearheaded" stuff. While that may speak to how well you have performed in non-acting jobs, it is not appropriate, necessary or needed information to go on the back of your head shot.

It is important that your resume be clean. By that, I mean easy to read, not too many words on the page, in a font that is crisp and clear, with the results being a document that both looks good and is filled with truths — about everything. Do not say you are 6'1" if you are really only 5'10". Do not say you are 110 pounds if you are really 125. If that co-star role in a feature film that shot in your hometown was really work you did as an extra, do not list it as a co-star role. In fact, I would make an argument about not listing it at all. More about that shortly.

Regarding the importance of honesty on a resume, I once had an actor come to me for possible representation who listed a credit on his resume for a theatrical production that, unbeknownst to him, I had been a producer of. He claimed to have appeared in that production. When I pressed him on it, he finally admitted that his cousin had worked in the box office. Enough said. I don't even think he saw the show.

Doing extra work in the beginning of your career or even from time to time for a while thereafter can be a good thing, if your ego is comfortable with it and if you are doing it for the right reasons. You will *not* get discovered by the director while working as an

extra and be bumped to a lead role. But if your exposure to a production set has been limited or nonexistent, doing extra work will provide you with an opportunity to see how the process works from as close a vantage point as you can get—and get paid for it. It is also a great way to meet other actors and people in some production-related jobs. But if you seek work as an extra, you should not work those jobs for social interaction and/or contacts alone. Rather, you should see extra work as a part of your continuing education in your early career journey.

Some information about casting directors and extra work: There are casting directors and casting agencies who only work in the business of securing extras for film and television productions. The names of reputable, franchised ones are available from SAG or AFTRA. Casting directors who are hired to cast the speaking roles in a production usually do not hire the extras. An agency that specializes in extra casting generally gets those assignments.

In order to be a successful extra, you have to know when to stop doing extra work. Although many actors make good livings as professional extras, sometimes even as regular extras on a television series, it requires a commitment that can make the pursuit of other acting opportunities difficult, if not impossible. Having said that, unless you want to be a professional, career extra, I don't believe that extra work should be listed on your resume.

I have never met a casting director who thinks extra work counts in the building of a long-term acting career. I can see the point. But I can also value the opportunity for the exposure to the process that a smart actor can get from the experience, if only temporarily. Whether it is a union or nonunion job, the exposure is all the same. It is just how much you get paid for your

time that varies (and there can be a huge difference between a union and nonunion extra job).

What a casting director wants to see on your resume is appropriate acting credits. If you do not have many, or any, appropriate or professional credits to put on the page, then it is important to show that you are serious about your craft. Demonstrate this by listing classes you have taken, workshops you have attended and educational training you have had toward your goal. In fact, this information should be included all the time on all versions, updates and revisions of your acting resume, even as your career grows.

An actor acts, but when you are not acting or working on the business of your career, you should always be in training. There is no better way to show a casting director or prospective agent or manager your level of dedication and commitment then by showing that working at getting better at what you do is something you value and work at all the time. Acquire this training by working in local theatre. Add experience to your resume by working in and on student films. Challenge yourself and stretch your acting skills by seeking out classes and opportunities that will grow you as an actor and as a person.

RESUME FORMAT:

As for the presentation and format of your resume—in other words, how it looks—here are some specific guidelines that can help make it stand out. Some examples of the finished product follow.

+ Your name at the top of the page, centered, in bold-faced type, 16-point font. I like the look of a font that is clean and com-

fortable on the eye, like Times or Bookman (nothing elaborate, nothing fancy).

+ If you are a member of SAG (or have SAG-eligible status), AFTRA and/or Equity, indicate that affiliation on the next line, centered, doubled-spaced and in 12-point font (not bold). If this does not yet apply to you, then skip to the next step.

+ If you currently have no representation, then double-spaced below your name, centered, in a 12-point font (not bold), list a contact number for yourself. An important sidebar note about your contact number: If you do not have a voice mail service, get one immediately. You should never, ever put your personal cell or home telephone number on your acting resume. This, of course, requires that you are diligent in checking for messages (even hourly), but I like the protection that a voice mail message service can provide you. They have become very affordable, and they are valuable tools. Make sure that your outgoing message is brief, professional and to the point. You will probably have a pager option to consider. I don't think there is a need for one if you can be responsible about checking for messages regularly.

+ If you are currently represented by an agent or manager, you should list that agency or management company name (and/or your specific agent or manager's name, if necessary or desirable) and the telephone number, double-spaced below your name, at the left margin. I like to see it all in 12-point font, with only the telephone number in bold. If you are represented by both an agent and a manager (or if you have commercial and theatrical representation at different agencies), place that listing directly

opposite the first listing at the right margin.

✦ Four line spaces down from that and at the left margin, you will put the first category header for the credits that will follow. I like to see all headers in 12-point font (everything from this point on will be in 12-point font), bold and underlined (all category headers will be bold and underlined).

✦ Credit listings are presented in three column entries across the page. Begin with the most recent credits and end with the oldest. The first column lists the title of the production in all capital letters and in quotes. The second column lists what type of role you played, not the name of the character you portrayed, in upper- and lowercase (i.e. featured, supporting, lead, stunt double, etc.; more about these descriptives shortly). The third column lists who the production was for or what kind of production it was (i.e., NBC-TV, syndicated, cable, etc.). Afterr your last entry in this category, double-space to begin the next category header.

✦ The order in which you place these categories does have some significance. Television or film should come first and second, followed by theatre (if you are a Los Angeles-based actor; if you are a New York–based actor, list theatre as the first category heading).

✦ When listing theatre credits, rather than listing the type of role you played, you can instead list the name of the character if it is an important or recognizable one. The third column in the theatre category should list the name of the theatre where the production was done and the city where that theatre is located.

If your work (in this category or another) was with an important or well-known producer or director, list that person after you name the production company or theatre.

+ The next category header should be Commercials. Never list commercial credits on your resume, unless you have gained some notoriety from a commercial campaign you appeared in. Instead of listing individual commercial credits (if any), simply write "Conflicts upon request." Even if you have never done a commercial, you should include this category and that statement. It merely indicates that if you are up for a commercial audition, the casting director can ask your agent or manager if you currently are appearing or have recently appeared in a commercial for a product similar to the one you may be called in to audition for. It basically means that if you were a principal actor in a commercial for McDonald's three months ago, chances are you will not get hired to do a Burger King commercial right away.

+ I like to see another category on acting resumes, if appropriate and if it works for you, called Related Experience. This is where you can list the professional work you do or have done that is related to your career as an actor. It could be seminars or workshops you taught or teach. It could be print modeling you do or have done. It could be a one-person show you may have developed as a showcase for yourself.

+ The next category I like to see is Training. This is where you will list all relevant and related training that you have had and/or are currently getting in the building of your career. Workshops, seminars, classes, coaching—list them all, but list

them honestly. Include your college education and degree if your major and/or minor was earned in performing arts or a related area.

✦ The next category is Special Skills. If you have any, list them here. Include only skills that would be appropriate and would actually qualify as special, such as magician, fire eater, fisherman, juggler, fluent in (fill in the blank—but make sure you really are fluent in any language you list), etc.

✦ Finally, make Personal your last category. Here is where you will put your height, your weight (be honest!), your hair color, your eye color.

✦ Proofread your resume for typos, spelling and margin/sizing. Remember, it has to be formatted to properly fit the back of your 8 x 10 photo. After you have done this and you are sure that it looks perfect to you, ask someone who has never seen it to give it a read. You would be surprised how many little things can get by your own eyes. Typos and misspellings can be unnecessary distractions to casting directors, agents, managers or other people reading your resume.

While these guidelines are suggestions for how your resume can look, your individual resume can also have a bit of your own style, as long as you keep it professional and appropriate. By the way, the words "star," "lead," "co-star," "co-lead," "featured" and "supporting" have become almost interchangeable. However, in general terms, "star," "co-star" and "supporting" references usually refer to work in television, and "lead" and "featured" references usually refer to work in film, but not always. Theatre credits tend

to follow a little of both, depending on your preference and the truth.

Here are a few examples of some of my clients' resumes that were created using these guidelines and suggestions. For actual use, they are printed on regular 8½" x 11" paper trimmed to fit their 8" x 10" photos. The sizes have been shrunk to fit these pages. You will also notice some variations in how the information is presented. But in general, the format is consistent.

LANCER DEAN SHULL

SAG/AFTRA/AEA

Representation:
Zanuck, Passon & Pace, Inc. Lemack & Company Management
Michael Zanuck **(818) 783-4890** Brad Lemack **(323) 655-7272**

TELEVISION

"THE LAST RESORT"	**Series Regular**	Fox Television
"THE INVISIBLE MAN"	Co-Star	USA Network
"MTV'S CELEBRITY UNDERCOVER"	Recurring	MTV Networks
"SUNSET BEACH"	Recurring	NBC
"TURBO POWER RANGERS"	Co-Star	Syndicated
"RED HANDED"	Co-Star	UPN

FILM

"SCRIBES"	Supporting	Short Film
"ECHOES OF ENLIGHTENMENT"	Supporting	Feature
"FAR FROM BISMARCK"	Supporting	Feature
(Winner, Best Comedy, 1999 NY Independent Film & Video Festival)		
"ZEN RUSH"	Starring	Feature
"TOTO"	Starring	Student Film
"DAILIES FROM THE WAYFARER"	Starring	Student Film

THEATRE/LOCAL & REGIONAL (partial list)

"DREAMBOATS"	Lead	Sidewalk Studios, Burbank
"CONVERSATIONS"	Lead	Fremont Theatre Center, South Pasadena
"THE RAINMAKER"	Lead	Sierra Madre Playhouse, Sierra Madre
"COME BLOW YOUR HORN"	Lead	Theatre of Independence, Kansas City

"FORTY CARATS"	Lead	Theatre of Independence, Kansas City
"TONY AND TINA'S WEDDING"	Supporting	4th Wall Productions (Tour)
"DICKENS' HOLIDAY"	Supporting	Missouri Repertory Theatre, Kansas City
"SCARY HAIRY SINGS SUCCESS"	Lead	Fremont Center Theatre, South Pasadena
"SOUTH PACIFIC"	Supporting	New Theatre Restaurant, Kansas City
"CAMELOT"	Lead	Blue Springs City Theatre, Kansas City

COMMERCIALS

Conflicts upon request.

TRAINING

Acting: Jason Alexander (master acting workshop), Dee Wallace Stone (scene study/cold reading), Richard Alan Nichols (The Actors Craft Studio—technique/scene study), Tracy Roberts Actors Studio (on-camera technique). Voice: Louis Colianni (Linklater technique).

SPECIAL SKILLS

Firearms, masonry, horseback, trumpet, PC and Mac, accents (Southern and standard British).

EDUCATION

B.S.B.A., Computer Information Systems, Central Missouri State University
Music Arts Institute of Independence

PERSONAL

Height: 5'7"; weight: 147 lbs.; Hair: blond; eyes: blue.

Henry Polic II
SAG/AFTRA/AEA

Representation:
Zanuck, Passon & Pace, Inc. Lemack & Company Management
Michael Zanuck (818) 783-4890 Brad Lemack (323) 655-7272

TELEVISION (Partial list)

"WEBSTER"	**Series Regular**	ABC
"WHEN THINGS WERE ROTTEN"	**Series Regular**	ABC
"MONSTER SQUAD"	**Series Regular**	NBC
"CELEBRITY DOUBLE TALK"	**Series Host**	ABC
"SHEENA"	Guest Star	Syndicated
"PROFILER"	Guest Star	NBC
"COSBY"	Guest Star	CBS
"NEWS RADIO"	Guest Star	NBC
"GOLDEN PALACE"	Guest Star	NBC
"SAVED BY THE BELL"	Guest Star	NBC
"THEY CAME FROM OUTER SPACE"	Guest Star	ABC
"A FAMILY FOR JOE"	Guest Star	ABC
"MURDER, SHE WROTE"	Guest Star	CBS
"THE APPLE DUMPLING GANG"	Guest Star	ABC
"THE INCREDIBLE HULK"	Guest Star	ABC
"CAGNEY & LACEY"	Guest Star	CBS
"FANTASY ISLAND"	Guest Star	ABC
"EIGHT IS ENOUGH"	Guest Star	ABC
"ALICE"	Guest Star	CBS
"MORK & MINDY"	Guest Star	ABC

FILM (Partial list)

"THE TRIAL OF OLD DRUM"	Co-Star	Feature

"KING B: A LIFE IN THE MOVIES"	Co-Star	Feature
"HOLLYWOOD CHAOS"	Co-Star	Feature
"SCRUPLES"	Co-Star	MOW/Pilot
"THE LAST REMAKE OF BEAU GESTE"	Co-Star	Feature
"RABBIT TEST"	Co-Star	Feature
"SCAVENGER HUNT"	Co-Star	Feature
"PRIVATE SCHOOL"	Co-Star	Feature
"OH GOD, BOOK II"	Co-Star	Feature

THEATRE/LOCAL & REGIONAL (Partial list)

"A CHRISTMAS CAROL"	Co-Star	Regional
"A MIDSUMMER NIGHT'S DREAM"	Co-Star	Regional (Musical)
"IS THIS YOUR LIFE?"	Lead	Zephyr Theatre, Los Angeles
"A COUPLE OF GUYS AT THE MOVIES"	Lead	Tamarind Theatre, Los Angeles
"PAL JOEY"	Co-Star	Long Beach Civic Light Opera
"1776"	Supporting	Long Beach Civic Light Opera
"THE FANTASTICKS"	Co-Star	Various
"ROOM SERVICE"	Co-Star	Pasadena Playhouse
"MAN OF LA MANCHA"	Co-Star	Various
"THE BOYS IN THE BAND"	Co-Star	Off-Broadway Theatre/San Diego
"THE LAST PAD"	Co-Star	Westwood Playhouse

ANIMATED SERIES/VOICE-OVERS (Partial list)

"THE SMURFS"	Tracker Smurf	Hanna-Barbera
"BATMAN"	The Scarecrow	Warner Bros.
Assorted villains		

SPECIAL SKILLS

Foreign and regional accents, ballroom dance, singing (baritone).

EDUCATION

MFA, Florida State University, School of Theatre

PAMELA ROYLANCE

SAG/AFTRA

Representation:
Zanuck, Passon & Pace, Inc. Lemack & Company Management
Michael Zanuck (818) 783-4890 Brad Lemack (323) 655-7272

TELEVISION

"LITTLE HOUSE: A NEW BEGINNING"	**Series Regular**	NBC-TV
"DAYS OF OUR LIVES"	**Series Regular**	NBC-TV
INTERACTIVE HOME SHOPPING SERIES	Co-Host	GTE MAIN-STREET TV
"SEVENTH HEAVEN"	Guest Star	WB Network
"MURDER, SHE WROTE"	Guest Star	CBS-TV
"FATHER DOWLING MYSTERIES"	Guest Star	NBC-TV
"MACGYVER"	Guest Star	ABC-TV
"REMINGTON STEELE"	Guest Star	ABC-TV
"HOTEL"	Co-Star	ABC-TV
"KNOTS LANDING"	Co-Star	CBS-TV
"DESIGNING WOMEN"	Co-Star	CBS-TV
"STARMAN"	Co-Star	NBC-TV
"SUPERIOR COURT"	Recurring	Syndicated

FILM

"HEXED"	Co-Star	Feature
"ADDICTED TO HIS LOVE"	Co-Star	MOW/CBS-TV
"THE DARK AVENGER"	Co-Star	MOW/CBS-TV
"DEADLY INTENT"	Co-Star	Feature
"ON OUR OWN"	Co-Star	Feature
"SLUMBER PARTY MASSACRE"	Co-Star	Feature

THEATRE

"CONVERSATIONS"	Lead	Fremont Center Theatre, Pasadena
"STEEL MAGNOLIAS"	Co-Star	Glendale Centre Theatre, Glendale
"THE MIRACLE WORKER"	Co-Star	Glendale Centre Theatre, Glendale
"ROMAN CANDLE"	Co-Star	Glendale Centre Theatre, Glendale
"PEACOCKS"	Co-Star	Deja Vu Theatre, Hollywood
"SABRINA FAIR"	Co-Star	Glendale Centre Theatre, Glendale
"DEAR RUTH"	Co-Star	Glendale Centre Theatre, Glendale
"A MIDSUMMER NIGHT'S DREAM"	Co-Star	Portland Civic Theatre, Portland
"SAME TIME, NEXT YEAR"	Co-Star	Mark Allen Theatre, Portland
"TWELFTH NIGHT"	Co-Star	Portland State University, Portland
"PLAY IT AGAIN, SAM"	Supporting	Cannon Beach Repertory, Oregon
"THE LITTLE FOXES"	Supporting	Cannon Beach Repertory, Oregon

PROFESSIONAL SPEAKING

Motivational keynote presentations.

Customized business training programs, seminars and workshops.

PERSONAL

Height: 5'8" Weight: 129

Hair: Blond Eyes: Blue

Start working on your own professional resume. Begin by compiling the information for all of the entries that will be included on your completed page. Create a format similar to the samples you have seen.

By the way, depending on your age, it is perfectly okay to include high school and college productions that you have performed in; just label them as such. However, if you are over 25, I would leave the high school stuff out, and once you pass 30, it is a good time to dump the college stuff, too. Besides, you will need the space for all of the additional professional credits you will have accumulated.

BIOS:

As they tell us on the A&E Network, every life is a "Biography" —and that includes yours. A bio is a handy tool for every actor to have. Knowing how to write one is also an important skill to master. At the very least, each time you appear in a theatrical production, you will be asked to supply one for the production's program. Sometimes casting directors and prospective representatives will request a brief bio too, along with your photo and resume materials.

CREATING YOUR BIO:

To create a full-fledged biography, you would need pages and pages. That is not what this assignment is about. This assignment is about creating a brief story, a profile of you, highlighting your acting career achievements. It is about painting a picture of who you are as an actor that is interesting enough to make someone want to know more about you.

The longer your career, the more you will have worked; the older you become, the more experience you will get. As you grow professionally, so will your bio. Keep it current. Put in new credits as you earn them; take out older credits as they become less important as your career develops.

BIO FORMAT:

Your bio should not run more than one page, doubled-spaced, and ideally, it will only be a few paragraphs. The bios I write are always headlined with the name of the person, in all caps, centered, in bold and in 16-point font. Centered directly under the person's name, in bold, 14-point, upper- and lowercase, I simply type the word "Biography" (without the quotes). The rest of the document is double-spaced, left and right margins justified, paragraphs indented and in 12-point font.

I use several bio versions for my clients, depending on the need for the bio and my intention in giving it to the person requesting it. If it is for a Playbill-type publication for a cast member profile in a play's program, I submit the shorter version, one that highlights only the most important and interesting aspects of the person and his or her career. On the other hand, if the bio is to be used to prepare a reporter, talk show host or researcher for a publicity interview, I send the most detailed bio I have available to provide the most useful, current and interesting information as possible.

Since your assignment will be to create your own short bio, here is a look at two examples of short-version bios. One is for Isabel Sanford, Emmy Award–winning star of the popular and long-running television series "The Jeffersons" (she wrote the foreword to this book). The second bio is on Laura Bryan Birn from "The Young and the Restless."

ISABEL SANFORD
Biography

Isabel Sanford has gained international recognition for her Emmy Award–winning role as Louise Jefferson on the hit comedy series "The Jeffersons."

Ms. Sanford had raised her family before deciding to pursue becoming a "movie star" full time. With her three children at her side, she boarded a bus in New York and headed for Los Angeles with her eye focused on Hollywood. Shortly after her arrival, during a Los Angeles production of the play "Amen Corner," she was spotted by director Stanley Kramer, who signed her for his motion picture "Guess Who's Coming to Dinner," in which she made her feature film debut.

She created the recurring role of Louise Jefferson on the enormously successful series "All in the Family." Four years later, she and husband George were spun off into a record-breaking series of their own.

Numerous television, film and stage credits have followed, including popular commercial campaigns for Denny's restaurants and Old Navy.

For her outstanding contributions to the national charitable community, Ms. Sanford was the recipient of an Honorary Doc-

torate of Humane Letters degree from Emerson College in Boston. She has established the annual Isabel Sanford Award at the school, a scholarship awarded to a minority student selected each year who is studying theatre, media and/or technical arts.

LAURA BRYAN BIRN
Biography

She has played the role of Lynn Bassett, the perpetually love-sick-and-single secretary at Paul Williams Investigations, for the last 12 years on CBS-TV's number-one daytime drama, "The Young and the Restless." It is a role that marked her television acting debut and one that has garnered Laura Bryan Birn an enormous and loyal fan following.

She was born in Chicago, and moved with her family to Connecticut when she was three. Laura got a taste of Broadway at a very young age. Her parents were avid theatre people and took her to see most of the hit shows in New York. She credits those outings with her being bitten by the acting bug.

Laura was accepted into the highly competitive and elite Northwestern University summer theatre program, and later she auditioned for and was accepted into the University of Southern California's acting conservatory program, from which she received a B.F.A. in drama.

It was shortly after her graduation that the young and restless actress made her television series debut on "The Young and the Restless."

Her other credits include "L.A. Law," "Single Women, Married

Men," "Cries Unheard," "Shattered Dreams" and "Risky Business," as well as regional productions of "A Chorus Line," "Evita," "Vanities," and "Crimes Of the Heart."

Start working on your own bio. Follow the format of the samples. Do not be intimidated. Like the life about which they tell, bios are meant, by their nature, to be works in progress. So just let it happen. When you are satisfied with what you have written, give it to someone you know to read. See if anything about the "you" you have written about piques their interest or prompts them to ask questions.

Take notes. Make the edits, changes and additions you think are necessary and then proofread your bio, twice. Then give it to someone else to proofread it for you.

Next, give it a run-through on the spell-check in your computer, but be mindful that a computer's spell-check is not always perfect. For example, it cannot distinguish between "there," "they're" and "their." That you will have to spell-check yourself.

When you are through with the two assignments from this chapter, you will have acquired another critical skill you will need and use as an actor: the fine art of creating effective resumes and bios.

UNIONS & ACTORS

T HERE IS MUCH MORE TO a discussion of unions than whether or not you are a member of one. But the issues of whether and when to become a member are a key part of what we will explore.

It is the goal of most young actors I talk with to join a union as soon as possible. Many think they have to. Joining the union refers to signing up with the Screen Actors Guild, the American Federation of Television and Radio Artists and/or Actors Equity Association. There is a perception among young actors (and even some older ones) that union status gives them clout, cachet and credibility that nonunion status does not. This attitude often works against an actor who is just starting out.

Ask any union actors who have been around for a while, and they will probably tell you that their union has not done much for them or their careers—and they would be right. It is not a union's responsibility to find you a job or keep you in a job once you've gotten one. Basically, it is the union's responsibility to establish

minimums for actors—minimums for work, minimums for residuals, minimums for how you are allowed to be treated on a set, minimums for conditions on a set and minimums for the dues you have to pay as a member.

Unions are not concerned with over-scale actors. Those $20-million-a-movie stars have very little to do with their unions. Their dues are paid by their business managers (it's a figure based on a percentage of the work you do), and that's about it. Their acceptable minimums are far different from the union minimums for scale actors and are established through negotiations their representatives undertake with business affairs people. In addition to sky-high salaries, they negotiate everything from bigger dressing rooms and better billing to publicity photo kill rights (those rights allow actors or their representatives to prevent certain photos from being used). All of this has nothing to do with the scale-level actor. For now, that's you.

The Screen Actors Guild (SAG) has jurisdiction over projects that are shot on film. The American Federation of Television and Radio Artists (AFTRA) presides over television and radio projects produced on video or audio tape. Actors Equity Association has jurisdiction over theatrical and live performances. Just because you are a member of any or all of these unions does not mean that work (or even representation) will come to you more easily, more often or even at all. In fact, if you are an actor who is new to the business, union affiliation can be the biggest initial obstacle on the journey of your career.

Let's look at the economics of union membership first.

In order to join SAG, you must find yourself a job that requires SAG membership of you or you must collect three vouchers from nonunion extra work in a SAG-sanctioned project. Each day of

extra work can generate one voucher, if they are made available. However, not all productions will make them available to all extras.

That is just the beginning. Then you will need to pay an initiation fee of $1,300 just to join (that figure is as of this writing; the amount can change as often as twice a year). Added to this,will be minimum dues, which you must pay twice a year for a total of $100 annually. Even if you never work in the given reporting period, you are still obligated to pay these dues or risk losing your status as a current, paid-up member.

A side note about other benefits available to union members: SAG, like the actors' unions, offers a health insurance plan for its qualifying members. The operative word here is "qualifying"— and it is not free. In order to get the opportunity to pay for SAG health insurance, you will have to earn a minimum amount of money. At this writing, it is $7,500—and not just once. You will need to continue to earn that minimum amount each year in order to continue to qualify.

A word about SAG-eligible status: Many actors, once they have accumulated their vouchers, immediately register their status with SAG, as well as their intention to join—as soon as they are required to do so. This allows them to delay paying the initiation fee and semiannual dues until they get a SAG job and have to join in order to work. Some actors believe that even SAG-eligible status gives them an edge over a nonunion actor. I do not believe, in reality, that that is true. Rather, I think it just delays the inevitable paying of the money with the added downside that can happened to an as-yet unknown actor with a union affiliation. More on this shortly.

It is much easier getting into AFTRA, and I think this ease of membership was one of the biggest hitches in the proposed

AFTRA-SAG merger that was defeated by a vote of both unions' members not long ago. Not surprisingly, most AFTRA members were for it; most SAG members were not.

Essentially, if you have the $1,258 needed for your initiation and initial dues payment, you can become an AFTRA member and have the authority to officially call yourself affiliated. AFTRA members can become eligible to join SAG, but they need to have been hired first for a job that requires them to be SAG members and they still have to pay the SAG initiation fee and then SAG dues, twice a year.

Two other ways into SAG membership are from work in an AFTRA project or work in a SAG-sanctioned student film. Once you have been a member of AFTRA for at least one year and are hired for a speaking role (*not* extra work), you become eligible to join SAG. If you land a speaking role in a SAG-deferred student film, you will also become eligible for SAG membership.

Actors Equity membership costs $800 to sign up, as well as dues payments of $39 twice a year, regardless of your income in or from Equity jurisdiction projects. To make those payments easier on Equity members who are also members of SAG or AFTRA, members can deduct $5 from their dues payments if they are paid-up members of either of the other two unions.

All unions have pension plans that can greatly benefit actors, if you qualify for them—and that's a big "if."

I have what I think is a sound perspective on why you should delay union membership as long as you can.

If you are a new actor, your goal should be to generate opportunities to build your resume, to make contacts and connections, and to develop your talent and skills. Aside from training and classes, you can only achieve these things by actually working in

acting jobs. There are a lot of opportunities for nonunion actors to work in a myriad of productions all over the country (and at sea—cruise ship lines constantly hire actors for work in on-board productions) that would not be open to them if they were union members. Yes, the union's stronghold is in the protection of actors' minimums, and yes, nonunion productions rarely pay actors at the same rates that union work does. However, as you build your career, it is the experiences you gain, not how much you get paid (or even *if* you get paid), that are valuable. As you build your resume, you will never put next to the acting credit whether it was a union or nonunion job, and you will never list how much (if anything) you were paid for it. So if it is experience and opportunity that count (and I believe that they *do* count—a lot), then the rest of it doesn't matter—in the beginning and in the long run.

The level of competition for roles can be quite different in the nonunion arena, as well. Since every actor wants to be in the union, and since once you are in the union you are prohibited from working on and in nonunion projects, there will be many actors who are unable to audition for these parts that you might be very right for.

As you build your resume, you will grow your ability and your potential. You will nurture your talent, and you will build your confidence from your opportunities to work.

AFTRA and SAG find themselves in rather interesting positions lately. There is still some bruising from the fight over whether or not to merge. There is still scarring from the long commercial actors' strike in 2000 and the near-theatrical strike in 2001. Add to that the competitive and controversial 2001 election for a new SAG president and the division of various political camps within

the union and you have an environment that needs some healing time in order for it to be 100 percent effective again in its mission. Still, nearly 600 new members are added to SAG's roster each month.

Changes proposed to the contract agents have with SAG and AFTRA for the representation of union actors have added another issue for the unions to manage, as has SAG's interest in seeing managers, currently unregulated, held accountable for the work we do and the service we provide. Chapter 4: The Business of Talent Representation looked at what is behind these proposed changes. For now, suffice it to say that some change is inevitable, but there will still be much discussion and compromise before that happens. In the meantime, unions still reign supreme over most of the business, and they no doubt will prevail, as will the stream of actors who will continue to flock to join their ranks.

A phone call to the membership departments or a visit to the Web sites of the unions will get you membership information, with all the details about how to join and the benefits of an association with each union. It may appear to be a lot to read through, but it is worthwhile reading if you are not yet a union member and want to learn about all the specifics of an affiliation with one or all of them. It is probably not a bad idea either, if you are already a member, to read up on your union(s), if you haven't in some time. It is important to stay in the loop of information.

You will find the unions' contact information listed in Chapter 14: Helpful Web Sites, Online Services & Other Resources for Actors. You will also find regular updates and revisions to the relevant information in this chapter at *www.thebusinessof-acting.com*.

To join or not to join? You will know when and if it's the right time. But remember, no union will serve you better than you will or should serve yourself.

A final note about unions: Just because an actor is a member of a union does not mean he or she is any more talented, experienced or qualified to work than you or any other actor. And just because you have gained union status does not mean that great things will happen for your career either.

My friend Greg Krizman, until recently SAG's communications director, tells me that, according to the latest statistics, of the approximately 100,000 members of SAG, only about 25% make more than the $7,500 a year needed to qualify for participation in the union's pension and health plan. What does this tell us? It signifies that as an actor, you have lots of work to do to get lots of work to do. Follow your business plan with diligence to lead you to the acting work you want to build the career you desire. Union health insurance is just one important benefit earned from your commitment.

Your career goals and desires have nothing to do with union membership—and that is important to remember. Achieving your goals requires that you understand your role in the bigger picture of your career and that you develop and utilize the tools and skills that will help you on your journey of achievements.

You can do it—and the unions will be there when you are ready for them. How will you know exactly when? Circumstance and opportunity will guide you. Don't rush it.

EMOTIONAL, PHYSICAL & FISCAL FITNESS FOR ACTORS

A HAPPY, HEALTHY ACTOR is a much better person to work with. Just ask any happy, healthy actor. Too often actors bury the angst they feel from stuff in their lives that they have no control over and project it places where it does not belong. Money also matters in the business of acting. Not the mega-millions you will one day earn, but the dollars you need for your survival now. Before you can take care of business, it is essential that you take care of yourself at every level. Your personal business plan must include three key areas that are often neglected by new and experienced actors alike. They are emotional, physical and fiscal fitness.

Let's look at each category separately and see why they are each important.

EMOTIONAL FITNESS:

How you feel about yourself has a direct connection with how you relate to the world and how the world relates back to you. Self-confidence matters, self-esteem matters and the belief that

you are worthy of the success you seek matters. The state of your emotional fitness can impact how you audition, if you even get to audition, how you perform and how you interact with others. This includes your friends, your colleagues, your representatives, casting directors and other actors. In short, everyone.

My friend Michael Zanuck, who heads the Los Angeles–based talent agency Zanuck, Passon & Pace, encourages actors not to form any solid opinions about the business, about their careers or about themselves as actors until after at least their first professional year in the business. Instead, "spend your first year being a sponge," he advises, adding, "Absorb what you can from the people you know, the people you meet and the situations you encounter." Michael stresses to actors, "Work hard at not letting yourself become cynical." I agree. Cynicism is an attitude that can only serve to derail you on your journey.

Kathleen Noone, a wonderful and gifted actress who won an Emmy Award for her work on "All My Children," seems to have a terrific and important take on the whole thing. Her contention is that actors beat up on themselves way too often. I couldn't agree more. The source of this is rooted in the feeling that many actors get that tells them that if things do not go exactly the way they want them to, then they have to blame someone for it. Most of the time, their default is to blame themselves.

Kathleen, who has a master's degree in spiritual psychology, leads unique group and individual sessions for and with actors to help them overcome some of these demons. If you are interested in learning more about her workshops, you will find her contact information in Chapter 14: Helpful Web Sites, Online Services & Other Resources for Actors.

Kathleen sees too often how actors abuse themselves emotionally. She should know. She used to do exactly the same thing,

until she discovered a better way. I see it all the time, too. At whatever point you are in your career right now, you need to stop and evaluate how you respond to the pressures and stress you feel the industry hurls at you and the pressures and stress you willingly or unwillingly hurl upon yourself.

Here is a helpful and healthful philosophy to work into your life: Learn from your experiences, don't burn from them. Work at *not* becoming too hard on yourself when things you wish would happen have not yet occurred. Work at *not* feeling personally responsible for the opportunities you feel you do not get. Instead, be proud of the small achievements you do accumulate. They really do matter as you build your career and your self-confidence.

I want to suggest that you look at your life as an actor with a black-and-white philosophy. We looked at this approach earlier in Chapter 2: The Transition From Student to Professional. It is worth looking at again and being reminded of how this approach will help you, if you let it. It's simple: When you go on an audition, you either get the job or you do not get the job. I believe that is the healthiest way to look at it. For actors who usually see things in bright, vibrant colors, I admit, I am asking a lot for you to learn to process your experiences differently. But if you do, you will see the difference it can make in your emotional responses to the situations and circumstances you will often find yourself in.

It makes sense in Chapter 2 and it is even more important now. That you didn't get the part because you think you were "too fat, too thin, not attractive enough, not the right size" has absolutely no place in your emotional response to an audition. The operative word here is, of course, *think*. Just because you *think* something

is true doesn't make it true. You either get the job or you do not: Black and white.

In fact, who actually gets a job often has nothing to do with anything concrete or any one thing you can put your finger on. Not getting a job is not your fault. To play that mind game is quite counterproductive to the learning process. In fact, it can stop the learning process entirely, at least long enough for the "I think I'll beat myself up over this (again)" process to take over. This is not healthy. This is not effective. You have to work as hard as you can not to do this to yourself.

While it is perfectly okay and normal to feel disappointment if you do not get a job you really wanted, it is *not* okay, ever, to blame yourself for not getting it. If you were prepared, if you were ready, if your behavior was professional, then there is no blame, there is no fault. If, in retrospect, you were not as prepared, as ready, as professional as you should have been, you will do better the next time. Remember, there will always be a next time.

This approach is important to remember and to utilize in other professional situations you will find yourself in beyond auditions, particularly when you are seeking representation. If the agent or manager you meet with decides not to take you on as a client, it is not something that you should beat yourself up about emotionally, either.

As in many casting situations, a decision to sign you or not to sign you will likely be based on factors that you will have no control over. These factors include how you would fit into the mix of the company's current client roster and whether or not you are perceived as being ready to be submitted for professional-level work. Remember that it is the clout of an agency, an agent or a manager that opens doors to opportunity for unknown artists.

You can understand why they would carefully and selectively guard how they use that clout. You will read more about this in Chapter 11: Publicity, Marketing & PR for Actors.

Perhaps, instead, you are too similar (type, age range, look) to an actor they already represent? The last thing you want to do is be in conflict with another actor at the same agency. If signed, given you or that other actor, which of you would be submitted? Generally it is the more experienced, the less risky, actor who would be touted by the company. So while not being signed by an agent or manager who you want to represent you may be disappointing, it could, in the long run, simply mean that it just wasn't the right place for you at that time.

One more important item to keep in mind: In casting, if you are not right for a particular role but were impressive at the audition, a casting director will be more open to auditioning you another time. The same holds true for agents and managers. If they choose not to sign you right now but were, nonetheless, impressed with you as a person and as an actor, you will be remembered. Doors to opportunity open all the time. Keep these people posted on your career developments as you move along on your journey. Paths often do cros and another time and a different set of circumstances might make you a very desirable client for them—and others.

Remember, too, that it goes both ways. As you build your career, you will meet many people who will want to be associated with you, broadening your options for all kinds of opportunities, including representation. You never want to burn a bridge—and that goes both ways, too.

It is important for you to learn where and when to put the brakes on your emotional responses to situations over which you have no

control. The best emotional preparation for an audition and for how you will feel following your audition is to prepare for that audition as much as you can and then do the best you can when it's your turn at bat. As important is learning how to forget about it once you are finished.

You read earlier (in Chapter 5: A Casting Director's Perspective) that you need to be prepared enough and confident enough in the choices you make before an audition to be able to go into that audition secure and comfortable with those choices. Consider this an important reminder. You should always walk away from an audition thinking one thing and one thing only: "If I had a chance to do it all over again, I would do *exactly* the same thing I just did."

Finally, it is important for you to have something else planned to do immediately after an audition. Meet a friend for coffee. Go to the gym. Take a yoga class. Have something to do instead of sitting around thinking about your audition and waiting, hoping for your cell phone to ring or your pager to go off. Having something else to do, something to take your mind off of your audition, will help you put the experience exactly where the experience belongs—within you, not consuming you.

That's emotional fitness.

PHYSICAL FITNESS:

An actor has to be fit. Notice I said "fit" and not "in shape." There is a big difference. What is important is that you recognize the need to take care of yourself.

While Hollywood continues to push the "you can't be too thin" message to vulnerable young teens and others, I hope that you will be smart and ignore that message. Recognize that size, ultimately,

does not matter. Actors are real people. Real people are all sizes and shapes. Real people are portrayed on television, in film and onstage every day. Recognize that you have your own unique look. I do not at all advocate that you change your physical appearance to fit into a Hollywood stereotype. There have always been and there will always be roles for all kinds and sizes and shapes of actors.

Some kind of physical activity (other than jumping to conclusions) should be a part of your life. Your physical fitness, regardless of your body type or size, is important because it can impact your endurance level when you are on a job. It makes sense to have some kind of regular regimen of cardiovascular exercise. Ride a bike, climb the stairs, go for a walk. An expensive gym membership is not necessary for any of these activities. It is just important that you do something and that you do it regularly.

If you have not exercised since high school gym class (don't laugh—there are a ton of people in this category, even thin ones!) or if it has been a while since your last workout, it is always a good idea to get checked out with your doctor before beginning any exercise program. Find out how your blood pressure is. Find out where your cholesterol level lies. Learn where you are on the health and fitness charts, and learn to take good care of the vehicle that will deliver your performances to the masses.

There is no doubt that stress can take its toll on you, too, if you let it. While acting itself may not be a stressful career, the act of being an actor and pursing your career, as you may have already experienced, can be very stressful. Taking care of yourself means working at lowering your stress level, too. While you may not be able to lessen your exposure to it, you can limit the impact stress can have on you. Walking, yoga, Pilates—there is a wide variety

of things you can do to promote relaxation. It does not have to cost you a lot or even anything at all. Many communities have high school systems where adult or continuing education programs and classes are offered in all kinds of areas, including relaxation techniques. Once you are able to learn how some of these exercises are done, you can re-create them in your own space.

It is easy for actors to fall into the bad habit of thinking they need to be on the go all the time in order for them to advance their careers and to never miss out on any opportunity. That is a self-destructive way of thinking. It is critical to your personal and professional development to recognize the need we all have for some downtime, some quiet time, on a regular basis. The pursuit of your career should not take a toll on you or on the body you need to achieve and maintain goals of success.

That's my definition of physical fitness.

FISCAL FITNESS:

Part I: Financial Survival

The very mention of "fiscal responsibility" is enough to bring on a panic attack in some people, particularly if you are recently out of school. Recent graduates usually find themselves facing pressure from their parents to get a job. Added to that is the pressure they put on themselves to get started with their chosen careers. It is also common to begin to feel overwhelmed, having just been dumped out into the real world by the school, college or university you graduated from. I hear this a lot. Whether you are just entering the real world or have been surviving in it for years, your fiscal fitness is vital to your health and to your career.

The three rules of fiscal fitness are:

1) You have to live somewhere and be able to pay for it.

2) You have to eat regularly and be able to pay for it.

3) There is a minimum amount of money that you must earn first to survive and then to thrive.

Our discussion of finances falls into two categories: living expenses and career expenses.

It is not the norm, nor is it reasonable to think, that you will finish up school and then land a series or a big movie deal within the first month after graduation. As much as we would all like for that to be the case, don't count on it. So what do you do? How do you live? How can you get by financially without compromising the start of your career and the pursuit of those opportunities?

Depending on your age, you have more or less financial responsibility on your plate. If you are in your 30s, 40s, 50s or beyond, it is a different picture than if you are in your 20s and just starting out. These rules, however, still apply regardless of your stage of life. It is not easy. But if you remain focused on your long-term goals and stick to your personal business plan, you can do it.

You have probably heard about actors who live in Los Angeles or New York who take jobs as waiters or waitresses or in some other kind of minimum-wage work in order to support themselves between auditions and acting jobs. Maybe you have already done exactly this. You probably are also aware that many actors take on temp jobs through an employment agency while pursuing their professional careers. You may have already had experience with this process as well.

If you have to have a job while your career comes together (and sometimes even thereafter), then securing a job in an environment that is conducive to what you want to do with your life can be extremely beneficial to you in logging personal achievements and a lot of exposure.

If you are in Los Angeles or New York (and many cities in between), temp jobs at entertainment companies, studios, ad agencies, or publicity or casting offices can provide you with both dollars and valuable experiences. They can also open doors for you to connections and opportunity.

My friend Eileen Harper Dresner is president of the Los Angeles–based temporary staffing firm Success Staffing. She sees a lot of actors who are looking for just these kinds of opportunities. How to keep it a positive experience? Learn from the mistakes of others. According to Eileen, the biggest mistake that actors, in general, make when they are on an assignment at a temp job is attempting to network on company time. She believes that this is the quickest path to getting walked to the exit door. Just because you are temping on a studio lot, or in an office where potential opportunity may be nearby, doesn't mean you can drop your head shot and resume off while you are there. Eileen means business when she cautions, "You just should not do it."

Her advice to actors echoes the advice from talent agent Michael Zanuck. "Be a sponge while on a temp job," Eileen says. "Learn what you can while you can and where you can without interfering with your ability to get the job done that you were hired to do." Eileen is right. Once you have proven yourself and earned some trust from the people you are working for, you might be in a good position to ask a supervisor or superior for advice on how you can best submit your material to people housed nearby. Perhaps he or she might even be willing to make a call or send a note on your behalf to open a door or two.

Professional protocol needs to prevail at all times, as well as the recognition that not everyone will be willing to help you and that sometimes your patience and focus will be tested. But in this case,

at least your rent will also get paid; these temp jobs can pay anywhere from $8 to $15 an hour.

I have met actors who are quick to offer up an argument against taking jobs in any area other than acting. They will ask, "What happens when I get an audition?" "What if taking the time off to go on an audition would be a problem where I work?" I counter by asking them how they plan to survive financially if they don't work. I also offer up a solution.

The answer is simple, if you just consider the hard facts. This is not meant to be discouraging, only realistic. The odds that you will be called for an audition more than once every week or two are rare for most actors. I am not saying that it cannot or does not happen. What I am saying is that it is not the rule for most actors. Even for more experienced actors, auditions (or offers to work) do not come as often as you might think they do (commercial auditions are a different story; more about that shortly).

When an opportunity does present itself for an audition, it's all in how you manage your time. Do the best you can to schedule that appointment during your lunch break. Take an earlier or later lunch, if you have to or if you can. If you will need a little extra time, ask if you can stay late to make it up.

It is important to tell any employer right from the start that you are an actor and that, from time to time, an audition will come up that may take you away from the office, the restaurant, the store, etc. Tell them, too, that you intend to have those appointments scheduled so as not to interfere with your responsibilities at work whenever possible.

I have never known of an employer to tell actors/employees who were upfront and honest about their situation that they could not work it out. Besides, if one of these auditions turns

into a job that turns out to be that golden opportunity you have been working toward, then you won't need the job you took time off from to make that audition anyway.

See how it all works out?

Commercial auditions can be a little trickier if you do not plan ahead. Commercial agents are generally given blocks of time ("windows") by commercial casting directors during which time the clients who are selected by the agent to audition can come in. When your commercial agent calls you with an audition appointment for a specific time, ask what the "window" is. Usually it is broad enough so that you can go within a range of hours that should not interfere with your work schedule. Do not be afraid to speak up and ask your agent that question.

Actors can tend to become so intimidated by their agents, or so afraid of annoying them, that when they do get a call for an audition the last thing they want to do is risk what they think would be ticking off the agent and appearing ungrateful by asking questions. As you read in Chapter 4: The Business of Talent Representation, you have a responsibility to yourself and to the career you are building to ask any and all questions you need or want to ask about any audition, so do it.

By the way, it is probably a good idea to keep some small collection of clothing items in your car. What if you are in jeans and your last-minute audition later today is for a character in a business suit? I have never heard of an actor who lost out on a job because of wardrobe, but nonetheless, to appear dressed in something appropriate for the role you are auditioning for doesn't hurt. I think it helps.

You should also make it a habit to write down in your date book or on your calendar exactly what it is that you wear to every

audition. When you get a callback, you are usually expected to return looking exactly as you did when you were first seen. Writing down what you wore will save your available brain space for line memorization, not wardrobe reflection, particularly if the callback is many days or weeks after your first audition.

FISCAL FITNESS:

Part II: Career Expenses

Let's look at career expenses and why it is important for you to keep track of them. First and foremost, they are deductible. As an independent contractor, you are your own business. As a result, you are allowed to deduct from your yearly tax returns the money that you spent on your career, also known as your business venture.

I am not an accountant or tax preparer, but I have paid enough attention to the professionals I have hired to do that job for me over the years to be able to relate some important advice and information to you on the subject. There are also good books on the topic and a slew of qualified people who do this for a living. My friends Lilian H. Fields, EA, and Christopher Debbini, CPA, have taught me well. I want to share some of those lessons with you.

In the beginning, even a young actor can benefit from a consultation with a professional tax preparer. The small fee you will pay will be well worth it in the long run. This person can see to it that you get all the deductions you are entitled to, at the percentage rate you are allowed, on every item you are allowed. For actors, a tax preparer who is experienced in the entertainment business is always preferable over someone who is not because some of our

legitimate deductions may be foreign to a lot of general tax preparers or accountants: items like hair care, the costs of taking and duplicating your head shots, your expenses to promote your career (in publications like the Academy Players Directory, subscriptions to online services and others), your subscriptions to the trades and other actor-focused publications. Even agency commissions you have paid and lunches with your agent, manager or other business associates are legitimate, deductible expenses.

The best way I have found to maximize the deductions you are entitled to is to set up a file system that will help you manage those year-end deductions throughout the year. Your practice of shoving receipts into shoeboxes has just ended.

Start by making a list of categories that your legitimate business expenses fall into. In addition to the ones mentioned above, yours might include telephone expenses (for your long-distance calls regarding your career), postage (for mailings of your photos and related business correspondence), printing expenses (of your resume, postcard mailings, etc.).

If you have a file cabinet, make some space in it for your new files. If not, buy a file box to use for organizing your business expenses for the year (you will use a new box each year). Assign one file folder to each of these categories and place them alphabetically into your file cabinet or box. Every time you incur a legitimate expense in doing the business of your career, get a receipt. Every time you are out on an audition and you have to pay to park somewhere, get a receipt. Every time you see a film to study the performance of an actor or actors for your own career benefit, keep that ticket stub.

Every time you pay a bill, whether by check, cash or credit card, make sure you have a receipt for that expense. For expenses like parking meters that you pay with loose change, create your

own receipt. Write on the back of each receipt any important information that will document that expense. Who was at the business dinner? What business did you discuss? What was that audition for? Get into the habit of filing your receipts promptly into the appropriate category files.

Keep a log of the miles you drive going to and from business-related appointments. Expenses incurred for gas, oil, auto repair and maintenance may also be deductible.

In early January every year, pull each of these file folders and add up the receipts they contain. Use a calculator that prints a tape of your individual entries and final totals. Calculate each file's contents twice to make sure you have added correctly, and double check the figures. Write the category title on the paper tape and circle the grand total you have for the year. Put the receipts back into the file, along with the paper tape.

As you add up your expenses in each category, keep a listing on a separate sheet of paper of the titles of your categories and the total figures you arrive at for each one listed. Once you have gone through all of your receipt files, you will have a set of figures that you will use to claim the writeoffs you are entitled to for that year.

Your worksheet might look something like this:

Your name: _____

Business expenses for the year: _____

Auto expenses: $ _____
Auto insurance: $ _____
Auto repair: $ _____
Books, publications, subscriptions: $ _____
Business promotion and entertainment: $ _____
Coaching, classes, seminars: $ _____
Commissions paid: $ _____
Demo tapes: $ _____
Hair care and makeup supplies: $ _____
Legal fees: $ _____
Mailing supplies: $ _____
Photos: $ _____
Postage: $ _____
Professional dues: $ _____
Publicist/publicity services: $ _____
Review of plays, films, etc.: $ _____
Tax preparation and accounting: $ _____
Telephone: $ _____
Travel: $ _____
Voice mail/paging service: $ _____

These are general categories that you can adapt to fit your own situation or as requested by your tax planner or preparer.

Deductions are always weighed against income. If you have more deductions than you actually earned in any given year, the IRS, if not your tax preparer first, will want to know how and why that happened.

It is true that you have to pay it out first before you can deduct it later, but you would be surprised just how many actors do not take advantage of the writeoffs they are legitimately entitled to. Learning how to be fiscally responsible early on in your career will only benefit you more later on as the dollars you earn each year keep growing.

It's all about business and economics and, while all you may want to do is act, you do not want to miss acting on an important benefit that all businesspeople share: the ability to deduct the expenses you incur in the process of doing business.

·

CHAPTER 10

The Laws of Perception & Behavior for Actors

Not too long ago, an acting student of mine raced into class, late, and with a story. There's always a story. One of the few things I have difficulty tolerating is lateness, a student's, a client's or my own. I think it is unprofessional and I think it is rude. You would never think of being late for an audition (although you would be surprised how often that really happens) or on a first date. I view classes and business appointments the same way. It also says a lot about how serious you are or are not about the business—any business.

This particular student was staying and studying in Los Angeles while participating in the college program where I am a faculty member. Emerson College in Boston offers a unique semester-long program of professional-level internships and academic classes for qualifying students who are studying performing arts and communications. This was one of those academic classes.

It was week three of the 14-week semester. Comprising mostly senior performing arts majors, the students had been spending their college careers thus far studying the art and technique, not

the business, of acting. Clearly, that was all about to change.

I stopped the discussion in progress and remarked to the late student that it appeared from his demeanor that there was probably an interesting story to explain why he was late to class. Of course, there was. I thought I had heard them all.

He went on to relate his experience trying to navigate through Los Angeles rush hour traffic in his attempt to be on time for class. He was late leaving his internship that afternoon, and, given that in Los Angeles you judge how long it will take you to get from point A to point B by time, not miles, he knew that his jaunt from Santa Monica to Burbank would be a grueling one, especially at 5:30 P.M.—and it was. He told of the stop-and-go freeway traffic and clogged side streets that he just wasn't used to dealing with in Boston. After all, he had just arrived a few weeks before to begin his semester in L.A.

As he approached his exit, he tried to get over to the far right lane from the center lane he had been traveling in. That lane, also moving at a crawl, was also an on-ramp to the freeway from another entrance. He put on his right signal and attempted to get into the exit lane. Not a single car would let him in. The exit was fast approaching and the last thing he needed was to miss it. He saw an opportunity to cut in between two cars and move over. As he attempted to do so, the car that he would have cut in front of sped up, making his move into that lane impossible. Maybe the driver didn't see him, or maybe the driver just didn't want to let him in. Ultimately, it didn't much matter.

Of course the traffic was moving slowly, so each driver could see the other quite clearly. As the other driver pulled past him, he yelled at her, in frustration, a directive that is not really necessary to print here. The point is, he yelled it, and there was no mistaking his choice of words. Responding to the verbal attack, the other

driver simply flipped him the finger before continuing on her journey. He slipped into the lane behind her and flipped a finger back at her as he exited, feeling that justice had been served and that he had enjoyed the luxury of having had the last word. Five minutes later he was entering the class, late.

Needless to say, both people came away from that encounter with a rather unpleasant perception about the other. It did not matter much at that moment whether she was a nurse or a nun or he a dentist or a doughnut maker. The only thing that registered was that each had made a judgment call about the other as a result of that one, unfortunate, five-second exchange. Too bad.

Not a pleasant experience, for sure, but also, unfortunately, not an unusual one. A lot of very calm, nice, wonderful people become the complete opposite when behind the wheel. Especially when they are late. I know.

We joked a bit about L.A. traffic, and I made the point that you can never tell in advance how the traffic will be anywhere in this city. Rush hour in New York, or any other major city for that matter, is no better. This helped me make the point that if you want to get anywhere on time, you absolutely must allow for everything and anything to happen that can slow you down, especially if you are headed for an appointment as important as an audition or a class. Even if you have to sit in your car and kill time, do it. Bring a book. Go over your lines. Wait for a better parking place. Get a cup of coffee.

Nothing will kill an audition quicker than if you are wrapped up in the stress of running late, instead of being focused on what you are at the audition to do. You would be surprised how many actors run late habitually, for everything, and think that it is okay.

Well, it is not okay, and one of your best bets to starting out on the wrong foot with a casting director, agent, manager or photographer is to be late for an appointment. Besides, what usually follows first when you arrive late is a conversation about the fact that you are late, and not a conversation about why you are there. It will kill your focus. I cannot stress this point enough.

So, back to the late student, who calmed down and joined in with the rest of the class in whatever the discussion was we were having when he entered the room.

Not all college students are acting novices, professionally speaking. Some are fortunate enough to have had a few opportunities to work professionally either before or during their college careers. Some students are from cities where opportunities exist, from time to time, for the locals to be hired for work on a location shoot of a major film. Others have been cast in local theatrical productions. With such an interest in and market for actors and audiences in this age range, a lot of casting directors are willing to see new, young and mildly experienced actors for smaller roles in larger projects, whether in Hollywood, in New York or on location.

This particular student was one of those people. He had had some experience doing location work in Boston before coming to Los Angeles. He wanted to take advantage of his time here to audition, in between his internship and his classes.

A few weeks before, when he first arrived in L.A., he had noticed a casting ad in one of the trade papers. The ad was for a particular production and a particular casting director who was seeking unknown actors in the 18-to-22 age range for small speaking roles in an upcoming project. So, this student, armed with head shots he brought from Boston "just in case," sent in his photo and limited resume.

As you read in Chapter 6: The Art of the Head Shot, what casting directors look at first, usually, is your picture. If you have the look they are seeking or a look they find appealing or appropriate for the project they are working on, the next move they will make is to turn over the picture and check out your credits and training.

With this particular call being more about a look, than about experience, all that really mattered here was the photo. This student's photo arrived and was tossed into a pile with hundreds of others. As the casting director's team of assistants began going through them, they separated them into two piles. One pile was for people who had "the look" and were to be called in. The other pile, well, we know about the other pile. This student's photo made the cut, and he was called in for an audition with the casting director.

His appointment was scheduled for the day following the freeway incident, the morning after the class he was late for. He was enthusiastically anticipating his audition.

The waiting room at the casting office was packed with people who had "the look." Actors were called from the waiting area into the casting director's office and then were out in seemingly less than a minute. Sometimes, if it's just "a look," it can be a very fast process. "Next on the list" finally referred to him, so in he went.

The casting director had head her down, scanning through a pile of phone messages. Without looking up, she told him to have a seat in the chair in front of her desk, and he did. Ten seconds later, when she was ready to officially begin the audition, she looked up at him. It was then that their eyes met for the first time—the first time since they met the day before. As you have probably guessed, the casting director was the driver of the other vehicle he encountered while trying to exit the freeway the previous afternoon.

In a split second, the dynamics had all changed. He was no longer the harried driver with the big mouth. Instead, he was an actor seeking a job. She was no longer the driver with the quick middle finger but, instead, a person in a position to hire him—or not.

Given their previous encounter, it is no surprise that her decision might have been based on something having nothing to do with his talent or his look.

Needless to say, he did not get the job.

This may be a long road to a very simple point, but this story makes the point better, clearer and stronger than any other way I know how to put it. Yes, you want a casting director to remember you, but not this way. Whether this student or the casting director was right or wrong when they were each behind the wheel does not really matter. What does matter is that each formed a lasting perception of the other. I will bet you that this student has a difficult time ever getting seen again by this casting director—all because he was late for class.

The critical lessons here are about the laws of perception and behavior. This student might be the next Brad Pitt or Tom Cruise, but he also might never get the chance to prove it to this one casting director. You may argue that as his career builds and grows, what difference could the perception of one casting director make? A lot. It will take many single opportunities along his career journey before he will arrive at his destination. He cannot afford to be derailed by anyone. No one can. You see, sometimes being a good actor is not enough.

Sometimes, learning the skills you need to build the career you want is not enough either. Far more important than what happens if someone else derails you along your journey is what can hap-

pen if you derail yourself. Unfortunately, it happens all the time and most of the actors it happens to have no clue that they themselves are to blame. All they do know is that they are not auditioning as often as they think they should. They are quick to blame others for their predicament, rather than taking a good look at how their own behavior and inappropriate actions may be working against them.

It is tough enough out there. You are your best sales force. You can also be your own worst enemy. Think before acting. Think again before reacting. You never know who is in the car next to you.

PUBLICITY, MARKETING
& PR FOR ACTORS

PUBLICITY, MARKETING AND PR for actors can encompass a broad range of activities. For our purposes, we will look at the use of these tools as a means to generate visibility, awareness and attention among talent agents, managers and casting directors during various phases of your career journey.

The first step most actors take is rarely the first step they should take. The default is to, at the very beginning of their professional journeys, immediately send a massive number of head shots, resumes and letters to agents and managers in a misguided attempt to seek any kind of representation at any cost. Lots of actors continue this practice throughout their careers. This is exactly what you do *not* want to do.

This approach does not work for a few simple reasons. Most actors do not take the time or put forth the effort to assemble an appropriate and professional presentation of themselves to send out. They do not do their homework to research where to send (and where not to send) their materials. Perhaps most importantly, they send their packages seeking representation at a time when

they are really not ready for professional representation at all.

Let's look at what this means.

More is not better. When they are ready to find their first agent or manager or a new agent or manager, most actors fail to take advantage of key sources of information available to them that can really help set their inquiries apart from others. This is information that could make a big difference.

Start with your actor friends and their actor friends. Who represents them? Ask professional teachers and coaches at the classes you take. Who do they know? Asking those you know and those who they know can be a tremendous help in learning about good talent representatives.

I am usually quick to say that there are two kinds of actors: those who hate their agents and those who are looking for other agents. The truth, actually, lies between these two extremes. There really are some actors who are perfectly happy with their representation and would be happy to talk with you about it, and perhaps even put in a good word or two on your behalf. Perhaps they have actor friends who have actor friends who have other agents or managers who they are happy with, too. Sometimes there is a boyfriend, girlfriend or significant other who works for an agent or manager.

In Chapter 4: The Business of Talent Representation, we looked at the differences between agents and managers. Now let's look at the differences between agents and agencies, and what that means to you when you seek to promote yourself to them for representation. While there are many categories of actors, there are also many categories of agents. For general purposes, let's consider the two most prominent categories: commercial and theatrical. Many talent agencies have departments and agents in both areas. Many specialize in one area or the other.

Because the commercial business is so often about the look of an actor and not necessarily about his or her resume first, it is often easier, especially for younger actors with limited experience, to secure representation in this area than it is for them to find a theatrical agent. It is all about numbers, really. For a theatrical project, a theatrical agent may make only two or three submissions per role from his or her client list. For a commercial project, it is quite normal for a commercial agent to submit ten or more clients for the same role. As a result, a commercial agent can have, and often needs, a much larger client list to meet the needs and demands of that industry.

Not all actors want to pursue work in commercials, but if you do and if you also have your sights set on signing with a great theatrical agent, there is no better way to get your foot in the door for theatrical representation then if you are already represented by the same agency commercially. I am not saying it is a sure bet, but I am saying that the process of finding theatrical representation can be made easier if you can get an introduction from your commercial agent, who just happens to work in the same office. My point: When seeking a commercial agent, first seek out an agency where other departments exist that you can potentially benefit from. Your research and the resources you develop can lead you to this information and to these agencies.

While we are on the subject of agent and agency differences, let me throw one more item into the mix: the difference between representation in New York and representation in Los Angeles.

Until fairly recently most New York–based actors did not sign with any single agent or agency, but, instead freelanced with several of them for both commercial and theatrical auditions and work opportunities. Essentially, whichever agent or agency got to

them first was the agent or agency that would be commissioned if they booked the job.

Things have changed a bit recently, with some agents and agencies actually signing some clients. But there are still many agencies (and agents) that won't sign actors exclusively but prefer to freelance with them.

The arrangement is quite different in Los Angeles. In L.A., when an agent or agency wants to represent you (and if you want to be represented by them), they sign you as exclusive to them. Competition between agencies over the same actor is nonexistent in Los Angeles. You can have only one theatrical and one commercial agent or agency, and while these two agents may be at two different companies, you are exclusive to each in his or her respective area.

Does this ultimately make it easier to find and secure representation in New York than it is in Los Angeles—or the other way around? The answer often depends upon whom you ask. However, what never varies is your own level of pro-activity which must continue full force regardless of which coast you are based on or who represents you.

The business of talent management is pretty much self-defined by individual managers themselves, regardless of where they are based. Should the regulation discussed in Chapter 4 come to us, that might change. But for now, the rules of management are open to interpretation and implementation by each manager—and often times by negotiation between each manager and his or her clients individually. This is important to remember if your personal marketing campaign includes targeting personal managers.

Now let's look at another source of contact information for

agents, managers and other industry professionals: your college or university's alumni relations department.

Schools keep all sorts of information on their alumni in various databases. Many schools ask these people to be available to fellow alumni to serve as professional resources. Many give permission for their contact information to be released upon request for just this purpose. The school's career counseling center is also a good place to start to gain access to this information. Sharing a common piece of background with someone whom you do not yet know, but want to know, can serve as a great door opener to him or her.

One of the biggest mistakes actors make in their search for representation is in assuming they can or should submit their presentation packages to any agency they want to. If you assume that any agency would be thrilled to get your submission and be lucky to have you as a client, you would assume wrong. You would also set yourself up for a disastrous mailing campaign.

Several things have to happen for an agent or manager to want to sign you: They have to like your look; they have to be impressed with your education and your post-school professional training; they have to see from your work-in-progress resume that you are serious about the business, regardless of your age; and they have to believe that it is a business-smart and economically beneficial investment for them to represent you. They also have to be confident that you have the talent to back up the effort they would make on your behalf. That is a pretty stringent list of requirements to meet and roadblocks to pass through successfully from just a single mailing.

I receive about 100 unsolicited submissions a month from actors

of all ages and all stages seeking first-time or new representation. Some talent agencies get 100 a week or more. If I could show you some of the materials I have received from actors, you would be aghast and amazed at what some people send in, believing it to be the best representation of themselves possible.

Their cover letters are bad, their photos are worse and their submissions are inappropriate. Do your research. If you want to be a professional dancer or model, do not waste your time sending your materials to agents or managers who do not represent dancers or models. If you want to have a career as an actor, submit your materials to appropriate representatives of actors. More about that in a moment.

As if inappropriate photo submissions were not bad enough, you would be amazed at the rampant problems I see with spelling, poorly photocopied letters, postage-due envelopes, multiple photos, miscellaneous support papers, etc., etc., etc. You would not believe it. The saddest part of it all is that these individuals have no clue that instead of attracting attention in a positive way for the representation they are seeking, they are being ridiculed, and their materials are being discarded as not being worth a serious look. It's too bad.

How can you avoid this happening to you? Let's establish some ground rules for sending unsolicited submissions to talent representatives.

+ First, if you have a mutual connection of any kind, use it and include the reference in your cover letter. It will help.

+ Second, ask yourself if you are really ready to be considered for professional representation or, if you want to make a change from your present agent or manager, if you are clear what you

are seeking by making the change and why. Have you assumed responsibility for your career by utilizing all the skills you have learned, or are you seeking a change because of what you feel "they" have not done for you? If asked why you want to make a change, what will you say that will not reflect negatively on you or those you are planning to leave?

+ Third, do you have the appropriate materials to submit? Do you have a head shot that really "pops"? Does it look like you look now? Was it professionally taken and crisply reproduced? Does your resume reflect your desire to learn and to train, whether your credits are limited or many? Is your resume cleanly reproduced and neatly attached to the back of your photo?

+ Fourth, have you done your homework to establish that the companies and people on your target list actually sign people like you? Do they represent newcomers? Do they welcome older, established actors? Do they represent nonunion talent? Do they seek character actors? Answers to all of these questions are readily available from any number of reference books and guides for actors, including many Web resources. Refer to Chapter 14: Helpful Web Sites, Online Services & Other Resources for Actors for information.

+ Fifth, have you created a cover letter that is to the point, businesslike and produced on appropriate business letter stock?

+ Sixth, have you checked the spelling of names and streets and verified addresses and titles of the people you intend to send to?

♦ Lastly, are you clear on what the exact purpose of your submission is? If your objective is to seek representation, chances are your envelope will never be seen by the person you have addressed it to and will be tossed out by an assistant. So what else can you do to ensure that this does not happen to you? Ask for help. By that, I mean that you should state right up front in your letter whether you are new to the business or not, that it is *not* representation you seek. Right now, what you are seeking is *information*.

Chances are better that you will get five minutes with someone for an informational interview than if you are actively seeking representation from him. What you *are* seeking is information *about* representation, as well as advice about how to find the best representation, but not necessarily from this agent. While you will certainly still attach your head shot and resume to your letter, it will be more in the guise of an "FYI" than for consideration to be signed.

Here are two examples of cover letters. One version is to seek the informational interview, if you are just starting out. The other is for seeking a change from your current representation. They will work just as well for agents or managers. I have used myself as the sample intended recipient of both.

For the informational interview request:

Today's date

Mr. Brad Lemack
Lemack & Company Management
c/o INGENUITY PRESS USA
P.O. Box 69822
Los Angeles, California 90069

Dear Mr. Lemack,

I have recently relocated to Los Angeles from Boston following my graduation from Emerson College.

I am writing to request a brief informational interview with you. It is not representation I am seeking now, but rather an opportunity to ask a few questions that can help me get to the next step.

I am enclosing my photo and resume, for your information.

I will call your office in a few days to follow up.

Thank you.

Sincerely,

Your name

Here is an example of a letter you might send if you already have representation but want to make a change:

Today's date

Mr. Brad Lemack
Lemack & Company Management
c/o INGENUITY PRESS USA
P.O. Box 69822
Los Angeles, California 90069

Dear Mr. Lemack,

I am seeking to make a change in my current representation.

I am attaching my head shot and resume, for your information. Can we meet?

I will phone your office in a few days to follow up. Thank you.

Sincerely,

Your name

Both letters are brief and to the point by design and intent. A letter that is to the point goes much further than a letter that is wordy or difficult to read. A letter that is formatted like a piece of business correspondence gets read more often than a letter that is handwritten or dashed off as a personal note. This is business, after all.

A misspelled name usually gets your envelope tossed faster than anything else will. Do not overdo it by including extra materials. One letter, paper-clipped on top of one black-and-white 8 x 10 photo with your resume neatly stapled on the back, is all you should send. Make sure that your personal contact information is easy to find and to read. Never send more than one photo. Do not waste your money printing and sending color head shots. Do not send clippings of reviews, articles about yourself or a bio. There will be plenty of time for that later.

The follow-up part is just as critical as the initial package. You wrote in your letter that you would follow up in a few days, so do it in a few days, not a week later.

You would be surprised how easily many people become tongue-tied and inarticulate in their attempts to have a proactive business conversation on the telephone. Usually it is nervousness that causes this, especially if you are new to the process. The best way to avoid sounding unfocused and to make sure that you get to say what you called to say is to practice your part of the conversation before you make the call. Think clearly about what you want to say. Make some notes. Jot down some key words. Be prepared to respond to whatever you hear in an appropriate and professional manner.

First you will probably speak with an assistant who has become an ace at screening calls, particularly the kind of call you are making. You never know to whom you are speaking when you place a call, so your default should always be courteous, friendly and professional with anyone you get on the phone. Never alienate assistants. They can be your greatest ally or your worst nightmare. They might also be the son, daughter, boyfriend, girlfriend, partner, significant other or spouse of the person you are trying to

reach—or they might be an actor, just like you, in a job that allows them to pay their bills, learn about the business and pursue their craft. I know many assistants at talent agencies and management companies, and most of them are great people who really do want to be helpful—that is, until the person on the other end of the phone says or does something to tick them off. Don't let that be you.

Keep in mind that many people who are assistants today will have their own agencies, casting offices or production companies in just a few years from now. You do not want to start out on the wrong foot with anyone.

The other critical issue here is whether it is the right time for you to be making your submissions at all.

Actors can get frantic about getting, having, changing or keeping representation because the thought of not having it seems to stir fears that they will never be able to get the kind of work they need for the growth of their careers. The truth is that there just are not enough agents and professional managers to represent all of the people seeking representation. As of January 2002, nearly 80 percent of the members of the Screen Actors Guild did not have talent agency representation.

Maybe these are actors who do not want agency representation, which is doubtful, or, more likely, these are actors who can't secure the representation they seek. On the other hand, there are also many people who seek representation who should not be seeking it right now at all, but they do so anyway and then fail to understand why they keep hitting brick walls.

How do you know when it is the right time to hunt for an agent and/or a manager? How do you make it the right time? You need to start building up and adding to your resume by doing

quality work wherever you can, work that is worthy of listing on your resume. You need to study and take classes as often as you can afford to do so. You have to work hard at getting noticed from the good work you do.

It is also important to remember that just because you may have gotten into one of the unions does not mean you are any more ready, or any more qualified, to join a company's client roster than an actor who has no union affiliation, but who has solid training and even minor credits.

Many agents and managers go to showcases and attend local theatre. Learn who the ones are who scout these venues. Create a list of agents and managers who take on clients like you, whether you are young and new or older and experienced, and then plan to concentrate your efforts on an outreach specifically to those people. Once you have built a bit of your resume or added some new, current credits, you can begin to implement a campaign that will target these individuals.

This is not a one-time-only proposition. These campaigns of visibility are personal business projects you will launch over and over again throughout your career journey.

Josh Schiowitz, whose talent agency, Schiowitz/Clay/Rose, recently merged with two other agencies to form The Talent Syndicate, is based in Los Angeles but also has offices in New York. He says that time constraints do not allow him to attend many showcases personally, but there are other effective ways for an actor to get his attention. If you are a younger actor, he will look at a photo and resume that you send to the office, as time allows. These quick looks necessitate your having a great photo that will quickly grab his attention.

"If you are an older actor, a photo alone will not suffice," Josh says. "I want to see your work." He will look at demo tapes, if available, and he also goes to see local theatre when he can, so informing him when you are in local productions where your work is good and where you have a part that is worthy of notice is important.

This information is invaluable. When you are in a play, let key industry people know about it through a postcard mailing. When anything new happens for you professionally, spread the word with another postcard mailing. This can be very beneficial to you. It is also a cost-effective way for you to get and keep your face and your name in front of casting people and talent representatives by simply informing them about what you are doing that might be of interest to them.

By the way, with regard to whether or not you should be an East Coast–based actor or a West Coast–based actor, Schiowitz advises that you let your career interests dictate where you should reside. "If you have a passion for theatre, then New York should be your home," Josh says. "If your passion is television or film first, then L.A. is the place where you need to be."

I agree. It is very difficult, if not impossible, for new or working actors to truly be bicoastal in a way that benefits both themselves and their agents. You can't be both places at the same time. You can't be in Los Angeles for an audition at 11:00 A.M. and then in New York for an audition at 2:00 P.M. the same day. Even if the auditions are days or weeks apart, economics does not allow for most actors to be traveling back and forth across the country for auditions. It is not feasible, nor does it make any sense. So pick where you want to be and focus all of your energy and all of your outreach in that location.

Let's look at postcards for this purpose.

At the same photo duplication shop where you ordered your 8 x 10 head shots, you can have postcards printed. On the front of the card put your photo and your name, basically creating a mini version of your head shot. On the back (address) side, I like to see a photo again, at the top, but much smaller, almost thumbnail-size, again with your name printed under it.

It is under this photo where you will write your message. When it comes time to address these postcards, take the time to personally address each one and not simply stick a printed address label on it. While typing cover letters and envelopes for your submission mailings is the only way to go for those campaigns, a postcard mailing allows room for more informal communication, so handwriting the person's name and address there is fine. Besides, the printed label will give your postcard the look of a mass mailing, which it may be, but it should not look it.

We produced a postcard for Lancer Dean Shull to spread the word about a guest appearance he had done in an episode of a television series. The purpose of the mailing was to inform the casting director community about his most recent work. It also served as a way for him to inform them that he had recently signed with a new agent and manager. We were able to get a production photo from the episode in which he appeared, and, since promoting his appearance in this episode was the primary focus of this mailing, we used it to his full advantage. Note the wording on his message. This is a very effective way to get your name and face out there and to keep it out there when you have something worthy to say.

Many an audition has been gotten because an actor's postcard arrived at a casting director's office at just the right time. Lancer's postcard generated auditions for him for two prime-time network drama shows within days of his mailing.

Front side:

Lancer Dean Shull
and
Gloria Stuart
in the "Father Figure" episode
of
"The Invisible Man"

Back side:

LANCER DEAN SHULL

I've just completed production of an episode of "The Invisible Man," which airs next week (August 24th at 8:00PM on the Sci-Fi Channel). It was a thrill to get to work with Gloria Stuart.

F.Y.I. I've also just signed with Zanuck, Passon & Pace for theatrical representation and with Lemack & Company Management

Zanuck, Passon & Pace, Inc.
(818) 783-4890

Lemack & Company
(323) 655-7272

This format can be adapted to fit the purpose of any mailing you want to do. I highly recommend it.

Getting access to all of the agents, managers and casting directors you want to meet will take some time. In the meantime, use your resources, develop your contacts and work at building your resume of credits and training. At any age, at any stage of your career, it is important that your passion for the business be reflected in the exposure you have earned and the experiences you have accumulated. Your resume is meant to showcase these achievements.

This is a business of connections. While it might be nice to be known among the masses, for most actors, it is far better to be known and respected by the members of your own entertainment industry community. Treat everything you do as another piece of business to conduct and to handle.

It is not fame and fortune from the business that should matter. It is the visibility and reputation you earn *within* the business that will benefit you the most. It requires cultivation and patience on your part, but the payoff can be significant. Positive, professional recognition is one of the most valued results of a well-planned career journey.

NOTES FOR THE BEGINNING
OF YOUR JOURNEY

I HAVE WRITTEN ten personal notes for you to keep handy as reminders as you begin your career journey. Copy them down into your date book, calendar or diary. Look at them often. Keep them as reminders of your mission. Use them as reminders of your goals.

+ I am a work in progress.

+ My career is a work in progress.

+ I will view and react to my experiences in terms of black and white.

+ I will stay clear about my mission.

+ I will gather my materials and the tools I need for use along my journey.

+ I will seek to acquire and develop the skills I will need to build my career.

+ I will begin my journey with energy, enthusiasm and healthy motivation.

+ I will temper my journey with patience, fortitude and self-reliance.

- ✦ I will live by a code of ethics that will serve to frame my intent along with my actions.
- ✦ I will follow my heart, follow my business plan and learn something new about myself and this business every step of the way.

AN ACTOR'S CODE OF ETHICS

WE ALL LIVE by a set of morals, standards and ethics that define our lives and our relationships. Add to the personal credo that guides you these 14 proclamations that will help your focus, your concentration and your attitude along your career journey:

+ I will be respectful of my fellow actors and helpful to them.

+ I will be supportive of my fellow actors, not competitive against them.

+ I will celebrate the successes of my fellow actors with them and not be jealous or envious of what may at first seem to me to be their good fortune.

+ I recognize that no fellow actor has the ability to take away from me any opportunity that is meant to be mine. We will each get what is ours to get.

+ I will not sell out.

+ I recognize that I do not now know everything that I am going to need to know to have the professional career I desire.

+ I will never doubt my ability, but I also recognize that my ability, like my potential, will grow only if I nurture it in a healthy environment.

+ I will value my friends and my family more than any professional opportunity, for I can be driven and motivated without becoming distant and removed from those I care most about.

+ I will always be true to my passion and to myself by recognizing that every professional journey needs a happy, challenged and fulfilled navigator.

+ I recognize that there is a difference between what I am given and what I earn.

+ I will never lose my true sense of self in the perception that others may have of me.

+ I will sometimes not talk but rather just listen to what the world around me and those I cherish have to say. I recognize that sometimes they will know more or better than I do.

+ I will give back to my community, my family and my friends in ways that say that I value what I have gotten from them.

+ If any day on my journey ever seems to be too great a struggle or delivers too great an accolade, I will remember, simply, that tomorrow is another day.

HELPFUL WEB SITES, ONLINE SERVICES & OTHER RESOURCES FOR ACTORS

THERE IS A MYRIAD OF SERVICES, resources and information available for actors. Here are some of them to get you started. Also, be sure to check our Web site frequently for relevant updates, news and information about topics covered in this book and revisions to these listings.

THE BUSINESS OF ACTING:

www.thebusinessofacting.com is the companion Web site for this book. The site contains free resources and information for actors, as well as information about upcoming *The Business of Acting* seminars and workshops. There is also an e-mail link for questions about the business, as well as timely news and information for actors.

ACADEMY OF MOTION PICTURE ARTS & SCIENCES:

www.oscars.org is the official information and resource Web site for the Academy of Motion Picture Arts & Sciences, the organization behind the Academy Awards and other programs and

services for actors, including an impressive and respected research library open to the public on a limited schedule.

ACADEMY PLAYERS DIRECTORY:

www.acadpd.org is the Web site for the Academy Players Directory, a publication of the Academy of Motion Picture Arts & Sciences, which is the industry's top directory listing and contact information resource about actors for casting directors, producers and other professionals.

ACADEMY OF TELEVISION ARTS & SCIENCES:

www.emmys.tv is the official information and resource Web site for the Academy of Television Arts & Sciences, the organization behind the Emmy Awards and other programs and services for actors.

ACTORS EQUITY ASSOCIATION:

www.actorsequity.org is the official Web site for the union of American theatrical actors and stage managers. They can also be contacted by telephone. Their New York office number is (212) 869-8530. The number for their Los Angeles headquarters is (323) 634-1750.

ACTING RESUME.COM:

www.actingresume.com offers an online service for $19.95 that will guide you through creating and printing a professional-looking resume. Free access includes links to other industry resources.

ACTORS SITE.COM:

www.actorsite.com is an LA-based information and community Web site for actors. Access is free, and there are many helpful

links. There is also the opportunity to purchase mailing lists and labels for agents, managers and casting directors.

AFTRA:

www.aftra.com is the official Web site for the American Federation of Television & Radio Artists. You will find news and information of interest to AFTRA members and others. The union can also be reached by telephone. The New York office number is (212) 532-0800; the number to their headquarters in Los Angeles is (323) 634-8100.

BACK STAGE AND BACK STAGE WEST:

www.backstage.com is the Web site for New York–based Back Stage and L.A.-based Back Stage West, the weekly newspapers for actors. For $9.95 per month, you get access to news, casting information and other resources on both coasts. You can also purchase subscriptions to the weekly print editions of one or both papers on their site.

BOOK SOUP:

www.booksoup.com is the Web site for Book Soup, an independent bookstore in Los Angeles that specializes in books about art and film. They can also be contacted by telephone at (310) 659-3110 or (800) 764-BOOK.

BREAKDOWN SERVICES, LTD:

www.breakdownservices.com is the Web site for Breakdown Services, Ltd., the subscription casting information service for agents and managers. Actors can get limited free access to some casting opportunities approved for release by a project's casting director.

Cast Net.com:

www.castnet.com offers a wide variety of fee-based services and resources for actors for $49.95 per year.

Coaching and Classes for Actors:

Noted character actor Basil Hoffman, who is also the author of the book "Cold Reading and How to Be Good at It," offers private coaching in Los Angeles for actors in preparation for an audition or in training for a role. For information, call (818) 247-0302.

Veteran actor and director Henry Polic II is available for private coaching in the Los Angeles area. For information, call (818) 763-3127 or contact him by e-mail at *hanktwo@juno.com*.

Brian Reise Acting Studios, in Hollywood, offers a variety of good classes for actors at all levels. For information, call (323) 874-5593.

Drama Book Shop:

www.dramabookshop.com is the Web site for this New York City bookstore specializing in materials on all aspects of the performing arts. It can also be reached by telephone at (212) 730-8739 or (800) 322-0595.

The Hollywood Reporter:

www.hollywoodreporter.com is the Web site for the daily trade paper The Hollywood Reporter. There is limited free access; you gain full access for a fee of $14.95 per month. Information about print subscriptions is also available on their site.

Income Tax Advice & Services:

San Fernando Valley (Los Angeles)–based Christopher Debbini, CPA, offers tax preparation and financial services for actors and others. For information and fees, call (818) 986-1040.

IMDB.COM:

This very useful Web site is the Internet Movie Database, *www. imdb.com*. It is a terrific resource for credits and background information on actors, producers, directors, casting directors and others.

ISGO LEPEJIAN CUSTOM PHOTO LAB:

www.isgophoto.com is the Web site for this Los Angeles–based photo lab specializing in photo reproductions of head shots. They have three walk-in locations in Burbank, Hollywood and Santa Monica. Check the Web site for addresses, hours and telephone numbers.

ROBERT KAZANDJIAN PHOTOGRAPHY:

www.kazphoto.com is Robert's official Web site, where you will find examples of his work and information about his head shot sessions. Los Angeles–based, he can also be reached by telephone at (323) 957-9575.

LARRY EDMUNDS BOOKSHOP:

This Hollywood bookstore specializes in performing arts and related books, as well as resource publications for actors and show business memorabilia. The telephone number is (323) 463-3273.

MICHAEL LAMONT PHOTOGRAPHY:

Michael is a Los Angeles–based head shot and production photographer. He can be reached by telephone at (818) 506-0285.

L.A. ACTORS ONLINE.COM:

www.laactorsonline.com is an L.A.–based online networking group and resource service. Access is $3.75 for the first month and $7.50 per month thereafter.

MAPQUEST.COM:

The enormously helpful Web site at *www.mapquest.com* will give you easy-to-follow directions from anywhere to any audition or any other place you have to be. Even if you think you know your way around town, this site is worth a try.

MARIO CUSTOM PRINT SHOP:

With locations in Hollywood and Studio City, Mario specializes in high-quality, digitally reproduced litho prints. For information, call (323) 461-3001.

KATHLEEN NOONE:

www.kathleennoone.com is the Web site for the L.A.–based award-winning actress who offers emotional coaching and counseling for actors. She can also be reached by telephone at (818) 980-7260 or by e-mail at *knoone@webtv.net*.

PILATES TRAINING:

Mark A. Saucedo is a Los Angeles–based certified Pilates trainer who offers private sessions at a Westside studio facility. For information, call (323) 574-3600.

PRODUCERS & QUANTITY PHOTOS:

This Hollywood-based photo lab specializes in head shot photo reproductions for actors. You can reach it by telephone at (323) 462-1334.

SAG:

www.sag.org is the official Web site for the Screen Actors Guild, offering news and information for SAG members and others. The

union can also be reached by telephone at (212) 944-1030 (New York headquarters) or (323) 549-1600 (Los Angeles headquarters).

SAMUEL FRENCH, INC.:
This bookstore chain has a long history of offering books, plays, monologues, audition materials and other resources for actors. Visit one of their shops in person or visit them online at *www.samuelfrench.com*. They can also be reached by telephone in Los Angeles at (323) 876-0570; in New York at (212) 206-8990; or in Toronto at (416) 363-3536.

SUCCESS STAFFING:
Eileen Harper Dresner is president of this Los Angeles–based temporary staffing firm. They place a high number of actors in temporary jobs in entertainment and other areas. For information on their services and how to qualify to register with them, call (818) 382-6588. There is no fee for applicants.

TALENT CLICK.COM:
www.talentclick.com is a fee-based online industry resource for actors and production professionals. Access is $79.95 per year.

TALENT WORKS.COM:
www.talentworks.com is a fee-based online community of actors and casting professionals you can join for $49.99 per year.

VARIETY AND DAILY VARIETY:
www.variety.com is the Web site for the daily trade paper Daily Variety and the weekly Variety. There is limited free access for nonsubscribers. Full access is free with a paid subscription to the print version. Subscription information is available on the site.

Women in Film:
www.wif.org is the official information and resource Web site for Women in Film.

These listings are provided for your information only. Their inclusion in this listing does not imply nor is it intended as an endorsement of or responsibility for the quality of the goods or services offered by the organizations, individuals or companies listed. The contact information was verified as accurate as of the book's publication date. Any revisions to the information provided, as well as new listings added since publication, are available at: *www.thebusinessofacting.com*.

ABOUT THE AUTHOR

BORN AND RAISED in Boston, Brad Lemack established Beverly Hills–based Lemack & Company Public Relations/Management in 1982 after serving as a publicity executive for Norman Lear's Embassy Television. Brad serves as the firm's president. The agency's management division specializes in the career development of a select list of new, younger actors and career growth and enhancement for more established, recognizable names.

Specializing in both talent management and public relations, Brad's concept is designed to develop and grow client careers while creating, generating and maintaining appropriate client visibility to the entertainment industry community and to the general public.

A graduate of Emerson College, Brad began his professional career in Boston as a television and radio talk show host, interviewer and reporter, as well as a producer of news and public affairs programming. He launched the news department at WQTV-TV as news director and news anchor prior to his move to Los Angeles.

In 1980 Brad accepted a position as a publicity executive at Norman Lear's Embassy Television where he was responsible for publicity for many of the company's hit network television series, including "The Jeffersons," "Archie Bunker's Place," "One Day at a Time," "Square Pegs" and others, as well as numerous specials and movies for television.

The launching of his own company opened the door to opportunity and exposure for him to other areas of the business that interest him, particularly the development, growth and visibility of actors' careers. In addition, he developed a passion for using entertainment, celebrities and his public relations background to benefit nonprofit organizations in their own development, growth and visibility in service to the community. He has won numerous awards for his work in this area.

In addition to his client and business responsibilities, Brad is a professor of performing arts and communication studies as a member of the faculty of Boston's Emerson College Los Angeles Center. He teaches "The Business of Acting," the popular, semester-long course he created and developed for students of the performing arts, and another popular course in entertainment and interactive public relations.

Brad also created and presents unique seminars and lectures on the business of acting, as well as innovative public relations workshops for nonprofit professionals.

He would like to hear from readers of *The Business of Acting* about how the book has been helpful to you. Your comments and experiences can be helpful to others in future, revised editions of the book. You can contact him in care of the publisher or by e-mail:

Brad Lemack
c/o Ingenuity Press USA
P.O. Box 69822
Los Angeles, California 90069 USA
or
blemack@thebusinessofacting.com

Photo Credits

Photos by Robert Kazandjian:
Allison Beal (page 84)
Adam Briggs (page 89)
Louis Goldberg (page 85)
Jeni4 Jones (page 86)
Brad Lemack (back cover)
Pamela Roylance (page 82)

Photos by Michael Lamont:
Laura Bryan Birn (page 88)
William V. Hickey (page 83)

Photos by Dave Segal:
Basil Hoffman (page 87)
Ned Wertimer (page 90)

Other:
"The Invisible Man" (page 164)
©2001 USA Cable Entertainment LLC